POSTCARD HISTORY SERIES

Lubbock

LUBBOCK, TEXAS · *Metropolis For A Vast, Rich, West Texas Area!*

LARGEST CITY WITHIN 90,000 SQUARE MILES is Lubbock, the geographical, trading, financial, industrial, commercial and educational center of the South Plains of Texas, a territory extending nearly three hundred miles north and south and an equal distance east and west, with railroads and highways radiating from the city throughout the area as spokes from the hub of a wheel. Lubbock's location in West Texas is shown by the star on the Texas map on the cover front.

LUBBOCK'S GROWTH has been phenomenal: 1910, 1,928; 1920, 4,051; 1930, 20,520; 1940, 31,853; and estimated 1943, 45,000. Growth of the South Plains has been equally startling: 1910, 29,392; 1920, 56,974; 1930, 162,606; and 1940, 190,674.

CLIMATE—Elevation 3,251 feet; mean temperature for winter 40 F.; for summer 77.5 F.; for entire year 53.8 F.; mean humidity 58.6, with approximately 3,550 hours of sunshine per year. Rainfall, 46-year average, 19.41 inches, of which 17 inches fall from April to October.

EIGHT CITY PARKS embracing 116 acres, equipped with playground, picnicking, swimming and other recreational facilities; Mackenzie State Park, 547 acres, adjoining the city; two country clubs with swimming pools, golf courses, club houses and other recreational facilities; and one privately owned golf course open the year 'round to citizens and visitors.

SOURCES OF INCOME—Over 3,000,000 pounds of dressed poultry are shipped out of Lubbock annually; and approximately 2,500,000 dozen eggs are handled by the produce houses each year. The city is the largest butter manufacturing center in Texas (4,700,000 pounds annually). The five cheese plants in Lubbock's territory each day convert over 100,000 pounds of milk into more than 11,000 pounds of cheese, approximately 20 per cent of the total cheese manufactured in Texas. And Texas ranks fifth in cheese manufacture in the nation. The city is also the concentration point for all South Plains cotton and is the third largest inland cotton market in the world.
Other crops—the grain sorghums, sudan, corn, wheat, dairy and poultry products, livestock and miscellaneous crops—bring the annual farm income of the South Plains to something like $75,000,000 to $100,000,000, much of which is spent in Lubbock.

OIL DEVELOPMENT—During 1941 and 1942—within 75 miles of Lubbock—1,606 new oil wells were completed in the Slaughter, Wasson, Seminole and Cedar Lake fields. More than 60,000,000 barrels of oil have been produced during the last five years in the North Permain district, all of which is in Lubbock's trade territory. The 2,915 wells of the area produced 18,875,757 barrels during 1942.

RETAIL AND WHOLESALE TRADE—Lubbock in the early '40's had 577 retail stores; 114 wholesalers, distributors and jobbers; 55 manufacturing plants; and 257 service businesses. These 1,003 businesses employed 4,273 people, with an annual pay roll of $4,038,186. Total retail sales during 1941 were $23,994,000; annual wholesale distribution amounted to $45,057,000; and the value of manufactured products was $9,022,000.

TEXAS TECHNOLOGICAL COLLEGE—The enrollment for 1942-43 regular session was 3,077, all of college grade. "Texas Tech" is now the third largest college in Texas, organized into four divisions: Agriculture, Engineering, Home Economics, and Arts and Sciences. Located on 2,008 acres of land adjacent to the city on the west, the investment is in excess of $5,000,000. Four dormitories have a capacity of 1,280. There are 166 faculty members.

LUBBOCK, TEXAS—METROPOLIS FOR A VAST, RICH, WEST TEXAS AREA!, c. 1943 (CURTEICH/ MCCORMICK COMPANY). This 1943 postcard folio by McCormick Company gives information and statistics on Lubbock during the early 1940s, including population figures and information on climate, parks, business, and Texas Tech. The cover of the folio is shown on the back cover of this book. (Courtesy of the author.)

ON THE FRONT COVER: LOCAL FREIGHT TRAIN DEPARTING FROM LUBBOCK, TEXAS, c. 1910 (STAR DRUG COMPANY SERIES). Prior to the arrival of the Santa Fe Railroad in 1909, Plainview was the closest rail point. Lumber and other materials had to be shipped from Plainview to Lubbock and cotton and other agricultural products had to be shipped form Lubbock to Plainview by wagon freight trains, like the one seen here leaving downtown Lubbock. The Nicolett Hotel can be seen in the background. (Courtesy of the author.)

ON THE BACK COVER: GREETINGS FROM LUBBOCK, HOME OF TEXAS TECH, c. 1943 (CURTEICH/ MCCORMICK COMPANY). This large letter linen postcard served as the cover for a postcard folio. Information pertaining to this card can be seen above. (Courtesy of the author.)

POSTCARD HISTORY SERIES

Lubbock

Russell Hill

ARCADIA
PUBLISHING

Published by Arcadia Publishing
Charleston, South Carolina

Printed in the United States of America

Library of Congress Control Number: 2010934679

For all general information, please contact Arcadia Publishing:
Telephone 843-853-2070
Fax 843-853-0044
E-mail sales@arcadiapublishing.com
For customer service and orders:
Toll-Free 1-888-313-2665

Visit us on the Internet at www.arcadiapublishing.com

In loving memory of my father, Thomas F. Hill, who taught me to love history; to my mother, Lola Hill, who always taught me to believe in myself; and to my wife, Ann—without her support and encouragement, I would never have been able to achieve the successes in my life.

CONTENTS

ACKNOWLEDGMENTS

I would like to acknowledge the cooperation of several local businesses in the production of this city history. Primary among these is the *Lubbock Avalanche-Journal*. Without their continued support of my pursuit of Lubbock's history, none of this work would have been possible. I am deeply indebted to them for their support and encouragement. I am also grateful for the support and encouragement of friends and colleagues from the Lubbock Independent School District, Texas Tech University, Lubbock Area United Way, South Plains Fair, and United Supermarkets. Unless otherwise noted, all images appear courtesy of the author. Parenthetical information contained in caption titles provides the postcard publisher where available.

INTRODUCTION

When the citizens of Lubbock celebrated the city's 100th anniversary in 2009, I became involved in several centennial projects with the local newspaper, the *Lubbock Avalanche-Journal*, including a yearlong blog on the history of the city, presented year by year. The blog was illustrated with my personal postcard collection as well as numerous newspaper pages and ads printed through the years. That blog eventually led to the writing of this book. Several images and historical texts used in that blog and subsequently in this book are provided courtesy of the *Lubbock Avalanche-Journal*.

Lubbock was officially incorporated on March 16, 1909. The history of the town, however, goes back to 1876, when Lubbock County was founded. The county was named for Thomas S. Lubbock, a former Texas Ranger and brother of Francis R. Lubbock, governor of Texas during the Civil War. In 1884, a federal post office inside the store of George W. Singer in Yellow House Canyon was named Lubbock. Two settlements grew in the area as farmers and ranchers began to migrate onto the High Plains. These two settlements, Old Lubbock and Monterey, agreed in December 1890 to abandon the two separate settlements and create a new town on a neutral site named for the county. On March 10, 1891, the town of Lubbock was elected as the new county seat, and the settlers began to arrive with their families. The large Nicolett Hotel, one of the early landmarks of the city, had been moved on skids when the two towns converged to the town square. The young town also boasted a school, several churches, a newspaper, a courthouse with a jail, a variety of businesses, and 50 to 60 homes.

Rail service was established by the Santa Fe Railroad in 1909, ensuring the continued growth and development of the city, and by the census of 1910, the city had 1,938 people. Passenger rail service was established in 1910, and by 1920, the population of Lubbock had grown to over 4,000. Between 1909 and 1925, several banks and schools, numerous commercial buildings, hospitals, a city hall, and a new courthouse were built as the city continued to grow and prosper. Starting in 1920, city streets began to be paved, many in brick. Today Broadway Avenue in downtown Lubbock is still paved with the bricks from this era. Also during this period, cotton farming replaced cattle and hog ranching as the principal agricultural occupation of the area.

Lubbock's first newspaper, the *Lubbock Leader*, was founded in 1891 but moved to Plainview in 1899, leaving the city without a reliable source of news and information. On May 4, 1900, the *Lubbock Avalanche* was founded by editor J. J. Dillard. In 1926, the *Lubbock Avalanche* purchased the *Plains Agricultural Journal*, creating the present-day *Lubbock Avalanche-Journal*. In 1923, Lubbock saw the beginning of home mail delivery and the construction of a new Lubbock High School just south of Broadway, where the Ragus Aquatics Center now stands. In February 1923, Gov. Pat Neff signed into law a bill establishing Texas Technological College. Lubbock won the contest for the site of the new school. With six buildings completed by 1925, the college opened with a total enrollment of 914 students.

The city's population had grown to nearly 21,000 by 1930, when Lubbock Municipal Airport opened north of town and the present-day Lubbock High School building was also completed. In 1939, the Lubbock High Westerners won the Texas State Championship in football after a Cinderella season.

During World War II, Lubbock was the site of an army air training base that was approved in 1941. The first class of aviation cadets reported to the Lubbock Army Flying School on February 25, 1942. The base was closed at the end of 1945 but was reactivated four years later as Reese Air Force Base, honoring Augustus Reese Jr., a Shallowater native who was killed during a bombing mission over Italy in 1943. The South Plains Army Airfield was established near the present location of the Lubbock Municipal Airport in June 1942 and served as the training facility for glider pilots in World War II. The contributions of these glider pilots are recognized at the Silent Wings Museum, which opened in 2002 in the original terminal building of Lubbock International Airport.

By 1955, due to continued growth and expansion of the city, the high school population of Lubbock was split to create Monterey High School, named for one of the original towns that merged to form Lubbock. This split created an intense crosstown rivalry that continues to the present day with the annual Silver Spurs game, played by the two rivals every football season since 1956. By 1965, continued growth brought about the need for another high school, and Coronado High School, named for the Spanish explorer Francisco Vasquez de Coronado, was built on West Thirty-fourth Street. A fourth high school, Estacado High School, opened in the fall of 1967 and was named for the early South Plains community of Estacado, which was located east of Lubbock on the Lubbock–Crosby County line.

Many historic and original buildings in the downtown area were destroyed by a powerful tornado on May 11, 1970. The tornado killed 28 people and injured over 1,750 others. The storm caused an estimated $135 million in damage, destroying over 1,100 structures and damaging over 8,800 more. A new civic complex emerged from the rubble of one of the oldest neighborhoods in the city. The Lubbock Memorial Civic Center, the Mahon Library, and the Texas Department of Public Safety were all part of the new developments following the tornado. Texas Tech University used debris from the destroyed homes and businesses near the downtown area to build a series of berms at its outdoor museum—what is now the National Ranching Heritage Center.

Known as the "Music Crossroads of West Texas," Lubbock has hosted many musical legends, including Lubbock's son, Buddy Holly, who attracted followers and inspired musicians all around the world. Today the Buddy Holly Museum is housed in the old Fort Worth and Denver Railway Station in Lubbock's historic Depot Entertainment District. The Depot Entertainment District is a collection of historic buildings along Buddy Holly Avenue that offer a wide variety of live music venues, restaurants, stage shows, sports bars, and a microbrewery. Several of Lubbock's landmarks from the National Register of Historic Places are in or near the Depot District.

Beginning as a dusty settlement of buffalo hunters and ranchers just over 100 years ago, modern Lubbock has grown into a thriving metropolis with a population of over 218,000. Lubbock continues to be the "Hub City" of education, commerce, agriculture, and health care. Thousands of visitors come to Lubbock every year to experience great music, shopping, fine arts, festivals, performing arts, historic attractions, museums, unique dining, Big XII sports, and entertainment.

One

AGRICULTURE
AND COTTON

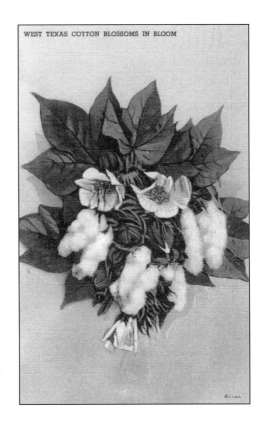

WEST TEXAS COTTON BLOSSOMS IN BLOOM, c. 1940 (CURTEICH). The back of this card states, "Since 1850, Texas cotton has clothed one-sixth of the world, annual production ranging up to 5,500,000 bales and being the livelihood for nearly half the Texans. West Texas excels in this vast cotton acreage, due to fertile virgin soil, ideal growing climate, and modern methods."

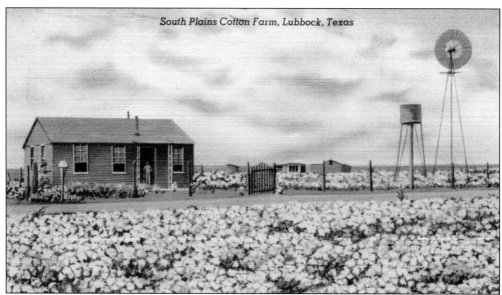

South Plains Cotton Farm, Lubbock, Texas

SOUTH PLAINS COTTON FARM, LUBBOCK, TEXAS, c. 1945 (COLOURPICTURE). In 1902, there were only four bales of cotton produced in Lubbock County. By 1919, the number of bales had risen to 13,865, and by 1932, over 100,000 bales were grown. The vast increase in cotton production was due to advances in mechanical farming, irrigation, and the development of commercial farming. Many local farmers began planting cotton in the 1920s and continued through the 1930s and 1940s. Here is a farm from 1945.

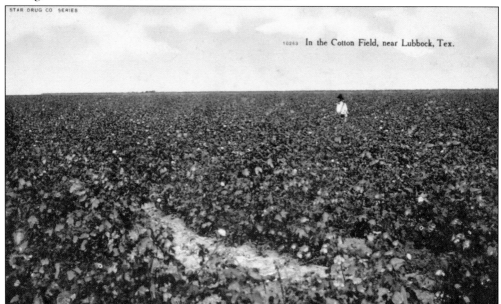

STAR DRUG CO SERIES

10269 In the Cotton Field, near Lubbock, Tex.

IN THE COTTON FIELD, NEAR LUBBOCK, TEXAS, c. 1932 (STAR DRUG SERIES). This photograph card depicts a farmer in his cotton field near Lubbock. In 1932, there was a bumper crop for the area with over 100,000 bales produced, ranking Lubbock County second in the state and fourth in the United States in cotton production. During this time, small farms, like the one pictured here, raised the bulk of the cotton rather than the large corporate farms of today.

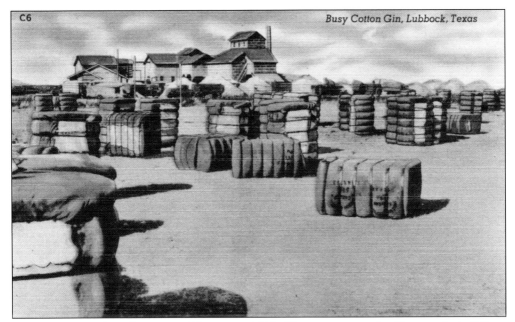

Busy Cotton Gin, Lubbock, Texas

BUSY COTTON GIN, LUBBOCK, TEXAS, C. 1945 (COLOURPICTURE). Cotton gin buildings are common sights on the South Plains of West Texas. The first cotton gin in the Lubbock area was built of wood covered with corrugated metal in 1905. It was powered by a steam engine and produced 700 bales of cotton. This 1945 postcard depicts a local cotton gin and its cotton bales.

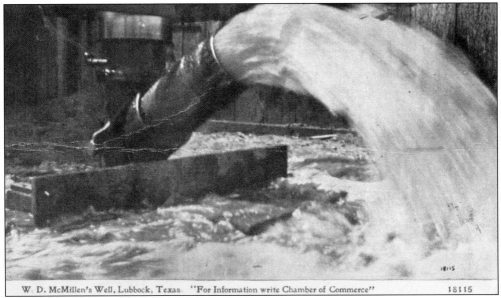

W. D. McMillen's Well, Lubbock, Texas "For Information write Chamber of Commerce" 18115

W. D. McMILLEN'S WELL, LUBBOCK, TEXAS, C. 1920 (C. U. WILLIAMS). One element that was important to the success of cotton and other agricultural products in the Lubbock area was the successful use of irrigation. The Ogallala aquifer lies under all of Lubbock County, most of the South Plains, and a large portion of the Great Plains. As early as 1911, Lubbock farmers had tapped into the aquifer to provide the much-needed water for their crops. This early photo postcard depicts one such irrigation well about 1920.

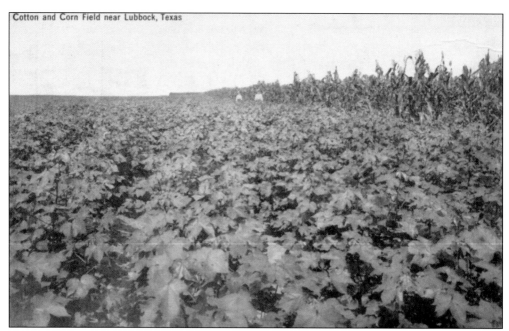

COTTON AND CORN FIELD, NEAR LUBBOCK, TEXAS, C. 1920. Lubbock County farmers produced a variety of agricultural products in addition to cotton. As cattle production increased during the 1920s and 1930s, so did corn, sorghum, and other cattle feed crops. This 1920 card is a real photograph of a corn and cotton field in Lubbock County.

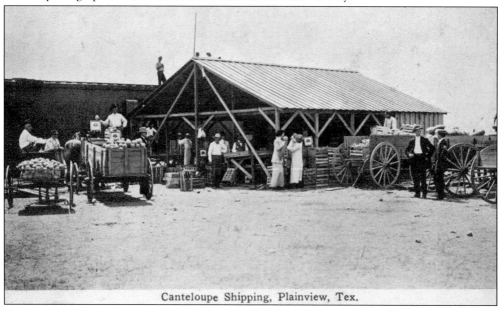

Canteloupe Shipping, Plainview, Tex.

CANTALOUPE SHIPPING, PLAINVIEW, TEXAS, C. 1920 (E. C. KROPP). The rapid expansion of Texas agriculture was primarily responsible for the vast migration of Mexican workers from 1900 to 1930. The development of cotton farms as well as large fruit and truck farming areas in Texas between 1910 and 1930 came about with the opening of new irrigation projects and the availability of cheap Mexican labor. This photograph card from about 1920 shows cantaloupe shipping near Plainview.

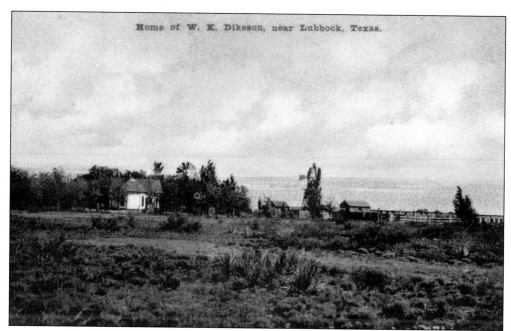

HOME OF W. K. DIKESON, NEAR LUBBOCK, TEXAS, C. 1925. This card illustrates a typical West Texas farm of the 1920s. The flat terrain and the ever-present windmill were the common features of the farms of this period. Windmills and wind pumps were used to drive water from farm wells for livestock and crops. Today the American Wind Power Center in Lubbock has on display over 40 rare and fully restored windmills from the late 19th and early 20th century.

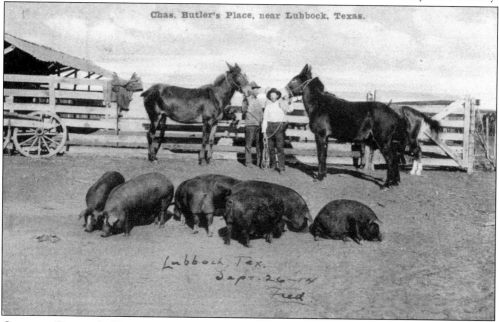

Chas. Butler's Place, near Lubbock, Texas.

CHARLES BUTLER'S PLACE, NEAR LUBBOCK, TEXAS, C. 1914. Horses and mules dominated the farm operations of the area well into the 1930s. Between the World Wars, hog production was on the rise in the county, but this business saw a rapid decline following 1945. This postcard of horses, mules, and hogs depicts the farm of Charles Butler in 1914.

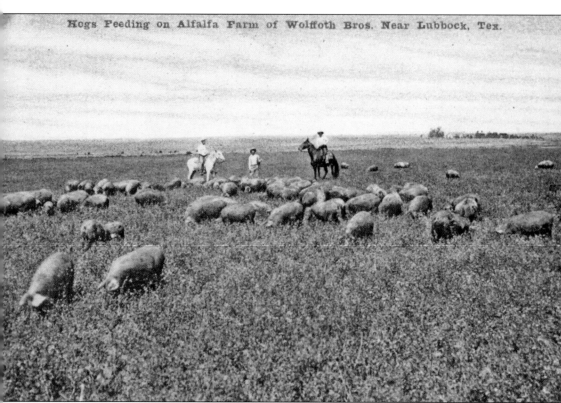

HOGS FEEDING ON ALFALFA FARM OF WOLFFORTH BROTHERS, NEAR LUBBOCK, TEXAS, C. 1915. The city of Wolfforth, 11 miles southwest of the city of Lubbock, was established in 1916 and named for two brothers, George and Eastin Wolfforth. George held various county offices and was later president of the Citizens National Bank of Lubbock. Eastin was a Lubbock County sheriff around 1900. Both brothers farmed and ranched in the area. This postcard depicts hogs feeding on alfalfa on the Wolfforth brothers' farm. There has always been confusion over the spelling of the name, and for a time, the post office and the railroad depot, which were both established in 1923, had different versions. (Courtesy of Handbook of Texas Online.)

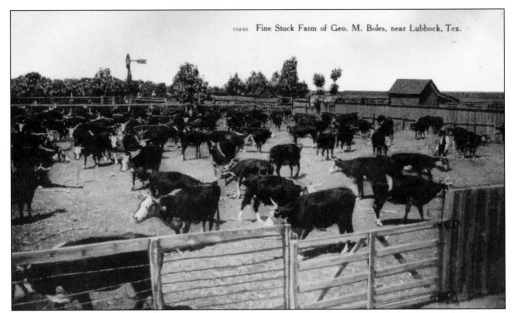

10260 Fine Stock Farm of Geo. M. Boles, near Lubbock, Tex.

THE STOCK FARM OF GEORGE M. BOLES, NEAR LUBBOCK, TEXAS, C. 1915 (STAR DRUG COMPANY SERIES). Beginning in 1887, the Four Section Settler Acts required that actual settlers could purchase one section of land classified as agricultural land at $3 per acre and three additional sections of pasture at $2 per acre. In 1890, one of the settlers who filed such a claim was George M. Boles, who became a prominent cattle breeder. Boles's herd was for many years one of the largest in the state.

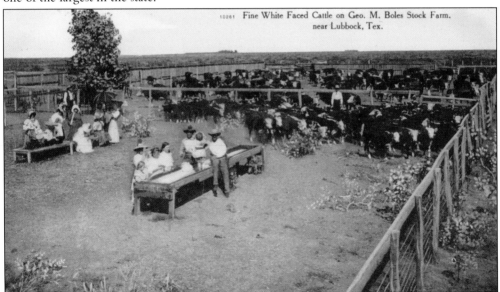

10261 Fine White Faced Cattle on Geo. M. Boles Stock Farm. near Lubbock, Tex.

FINE WHITE FACED CATTLE ON BOLES'S STOCK FARM, NEAR LUBBOCK, TEXAS, C. 1915 (STAR DRUG COMPANY SERIES). Boles's ranch was located along the Yellow House Canyon Draw and Buffalo Lakes. George M. Boles is considered a pioneer in the South Plains, serving as a county commissioner from 1907 to 1912. He started the first Hereford ranch in the Lubbock area and soon had the largest registered herd on the South Plains. This photograph postcard shows his herd of Hereford cattle.

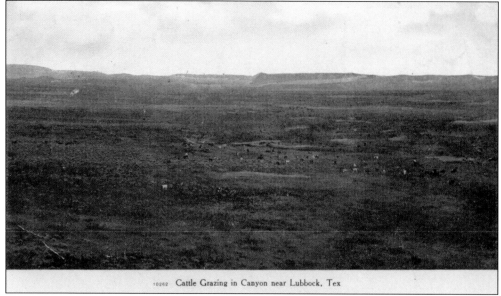

Cattle Grazing in Canyon near Lubbock, Tex

CATTLE GRAZING IN CANYON, NEAR LUBBOCK, TEXAS, 1909 (STAR DRUG COMPANY SERIES). This image of grazing cattle in a canyon could be part of the Two-Buckle Ranch in Blanco Canyon in Crosby County. At its peak, the ranch was stocked with nearly 14,000 head of cattle and covered over 200 sections of land in Crosby County. The Panic of 1893 caused the owners to go out of business and sell the entire herd. Over the next several years, the ranch was leased and eventually parceled out to various owners.

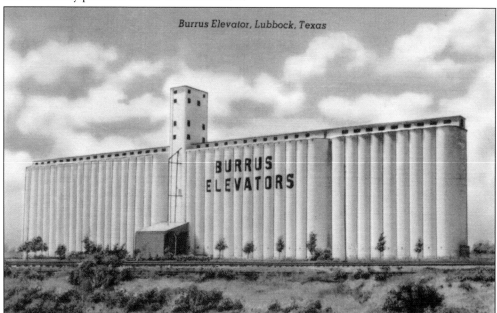

Burrus Elevator, Lubbock, Texas

BURRUS ELEVATORS, LUBBOCK, TEXAS, C. 1940 (COLOURPICTURE). The Burrus Grain Elevators, pictured here, were constructed in 1928 on Fourth Street and Avenue P. The structure was 750 feet long, 160 feet high, and consisted of 123 storage silos. The elevators were visibly one of the only standing structures in the area following the 1970 tornado. The Burrus Elevators were demolished in May 2004 to make way for the Marsha Sharp Freeway.

Two

Buildings and Businesses

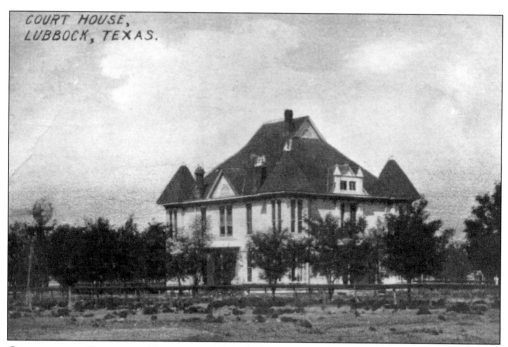

COURTHOUSE, LUBBOCK, TEXAS, C. 1900. This postcard depicts the first Lubbock County Courthouse, located in the center of the town square. This courthouse was constructed in 1891 and was used for county business. It was also used as a meeting place by several of the local churches. In addition, numerous community events were hosted here. When the new courthouse was constructed in 1915, this old wood frame courthouse was moved to the corner of Tenth Street and Avenue G.

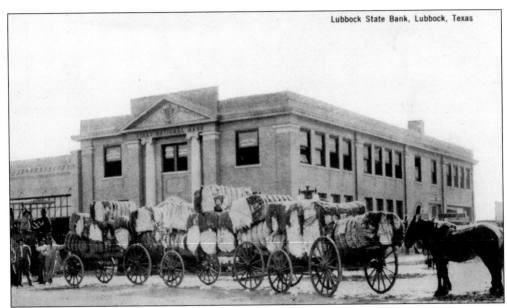

LUBBOCK STATE BANK, LUBBOCK, TEXAS, c. 1918. This postcard depicts the Lubbock State Bank at Main Street and Texas Avenue. Also knows as the First National Bank, the bank dates back to August 5, 1901, when it was established as a private bank and was known as the Bank of Lubbock. In April 1902, it was chartered as the First National Bank of Lubbock, and it later operated as Lubbock State Bank from 1915 to 1925. There are four wagonloads of cotton bales in front of the bank in this 1918 postcard.

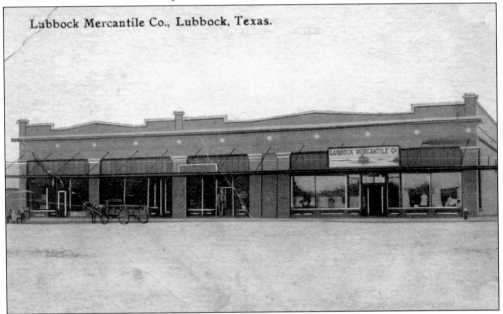

Lubbock Mercantile Co., Lubbock, Texas.

LUBBOCK MERCANTILE COMPANY, LUBBOCK, TEXAS, 1916 (LUBBOCK DRUG COMPANY). The Lubbock Mercantile Company was originally located at Broadway and Texas Avenue on the southwest corner of the square. This building was destroyed in 1911, when a fire started in the basement and spread to several wooden buildings in the area. This 1916 postcard shows the rebuilt business.

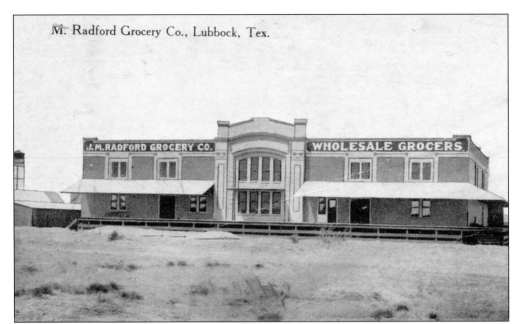

J. M. Radford Grocery Company, Lubbock, Texas, 1916 (Lubbock Drug Company). Here is the J. M. Radford Grocery Company in 1916. This was one of a chain of wholesale grocery stores that were operated by James M. Radford of Abilene. During the time of this photograph, this chain was the third largest grocery chain in the state of Texas, operating stores in Abilene, Cisco, Colorado, Stamford, Sweetwater, Big Spring, Ballinger, Alpine, and Lubbock.

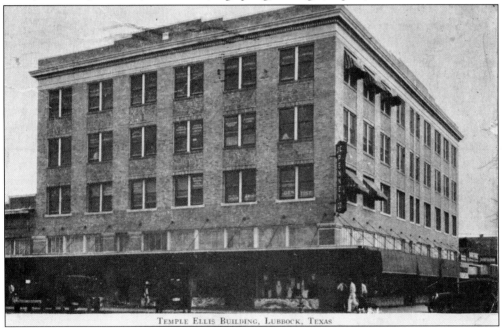

Temple Ellis Building, Lubbock, Texas, c. 1930 (Haskell Postcard Company). This postcard is a photograph of the Temple Ellis Building, which housed the J. C. Penney store in Lubbock. J. C. Penney opened this store on August 7, 1925. Temple Ellis was a local businessman and one of the original owners of the Lubbock Mercantile Company.

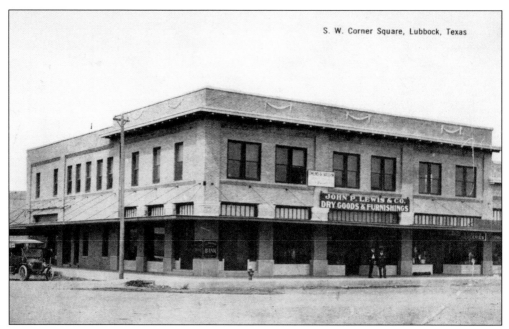

S. W. Corner Square, Lubbock, Texas

S. W. Corner Square, Lubbock, Texas, c. 1918. Shown on the southwest corner of the town square around 1918 is the John P. Lewis and Company Dry Goods and Furnishings business. Lewis opened his Lubbock store in 1908 and was the most prominent dry goods dealer in the county.

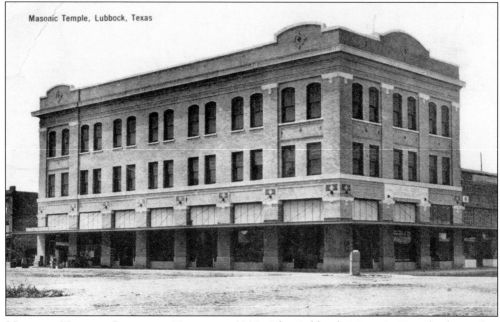

Masonic Temple, Lubbock, Texas

Masonic Temple, Lubbock, Texas, c. 1916. The Lubbock Masonic Temple, located at 1207 Main Street, is shown in this 1916 photo postcard. The temple was demolished in 2007 to make way for parking and renovations that were connected to the Pioneer Hotel project in downtown Lubbock.

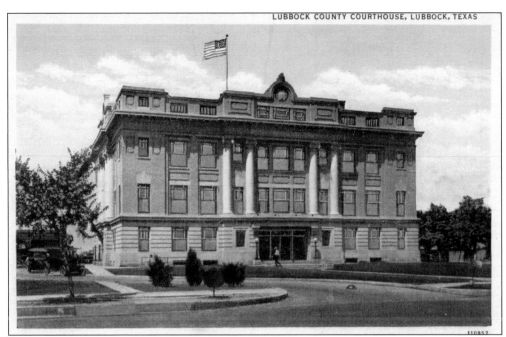

LUBBOCK COUNTY COURTHOUSE, LUBBOCK, TEXAS, c. 1935 (CURT TEICH AND COMPANY). This postcard depicts the second Lubbock County Courthouse. This courthouse was built in 1915 and housed offices for the city until city hall was built in 1923. When the third courthouse was built in 1950, this old courthouse was still used for a variety of county offices until it was demolished in 1968 to open up Avenue H through the two-block square.

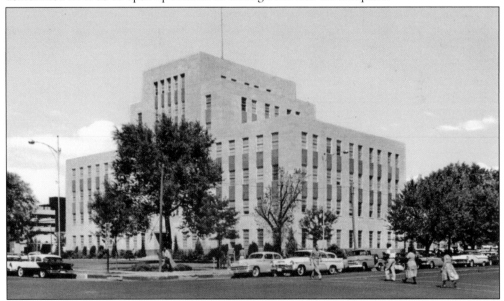

LUBBOCK COUNTY COURTHOUSE, LUBBOCK, TEXAS, c. 1955 (CURTEICHCOLOR). In 1950, the third Lubbock County Courthouse was built just to the west of the second courthouse. This limestone and granite building was completed in 1950, with an addition added in 1968. This is the courthouse that is still in use today. The gazebo in front of the courthouse is host to a summer concert series for local musicians.

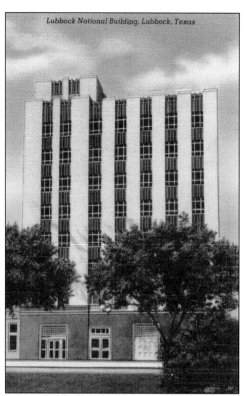

Lubbock National Building, Lubbock, Texas

LUBBOCK NATIONAL BUILDING, LUBBOCK, TEXAS, C. 1940 ("COLOURPICTURE"—MARK HALSEY DRUG). Lubbock National Bank grew from the combination of Security State Bank and Trust Company and the Farmers' National Bank of Lubbock. With Charles E. Maedgen as president, these banks merged in 1925 as Lubbock National Bank. The confidence of the president and the investors kept the bank open during the Depression, and by October 1940, this new eight-story bank building was completed in downtown Lubbock.

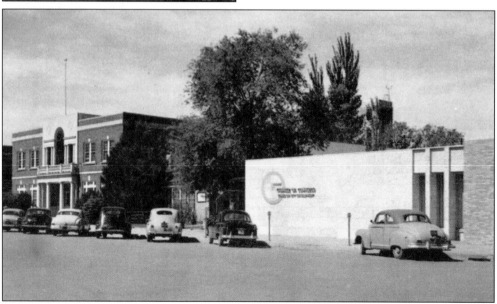

CITY HALL AND CHAMBER OF COMMERCE BUILDINGS, LUBBOCK, TEXAS, C. 1950 (DEXTONE— HERALD PHOTOGRAPH). This version of Lubbock City Hall was located at Tenth Street and Texas Avenue and was constructed in 1924. In 1984, city hall moved to its present location at 1625 Thirteenth Street, the site of the old Sears, Roebuck, and Company store. This card states, "Ultra modern in appearance, the chamber of commerce is often called the 'Community Workshop' because it serves as focal point of many community activities."

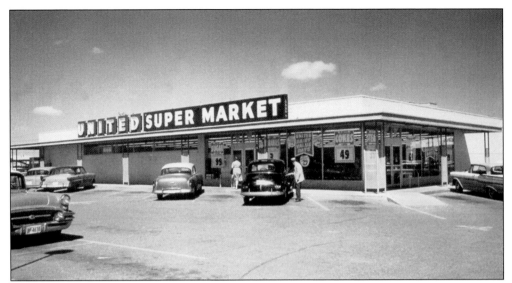

UNITED SUPERMARKET, FOURTH STREET AND IDALOU HIGHWAY, C. 1960. Lubbock became United Supermarket's official hometown in 1956, when the company purchased three Taylor Safeway stores. The company got its start in 1916, when H. D. Snell, the great-grandfather of current copresidents Matt and Gantt Bumstead, opened his first United Cash Store in Sayre, Oklahoma. H. D.'s son, H. D. "Jack" Snell Jr., purchased the company's existing stores in Vernon and Wellington and established a separate Texas company in the late 1940s. (Courtesy of United Supermarkets, Inc.)

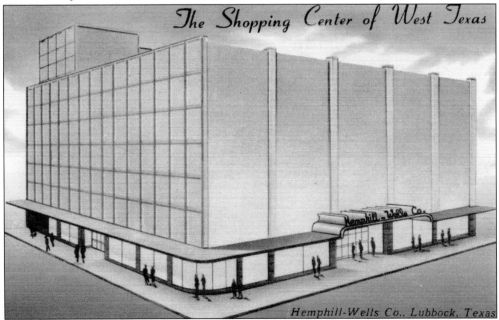

HEMPHILL-WELLS COMPANY, LUBBOCK, TEXAS, C. 1960. As early as 1900, W. M. Hemphill and Spencer Wells worked together at the Hemphill-Baker store in San Angelo. In 1925, the company opened a branch in Lubbock named Hemphill-Price, which later changed to Hemphill-Wells. From the 1940s through the 1970s, Hemphill-Wells was considered the finest department store in Lubbock. This is a colortone postcard of the downtown store at 1212 Avenue J.

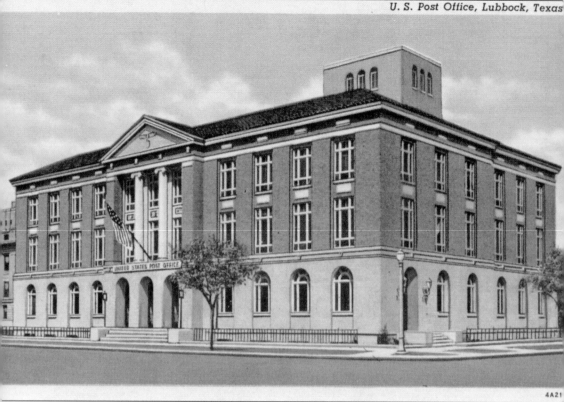

4A21

U.S. POST OFFICE, LUBBOCK, TEXAS, c. 1935 (CURTEICH—CHICAGO). Chamber of commerce officials began writing to postal authorities as early as 1923 to build a new Lubbock Post Office. When heavy rains collapsed the roof of the existing post office on May 30, 1926, for the second time in nine months, postmaster John L. Vaughn appealed to public and private organizations to lobby government officials for a new and well-built federal building. Construction of the new facility began in May 1931 and was completed in 13 months, with much of the work done by the Work Projects Administration, a Depression-era government program created by Roosevelt's administration. This postcard depicts the 1930s-era post office building, located at 800 Broadway. It was closed in 1968, when the new postal facility was opened at 1515 Avenue G. The old post office is listed on the National Register of Historic Places.

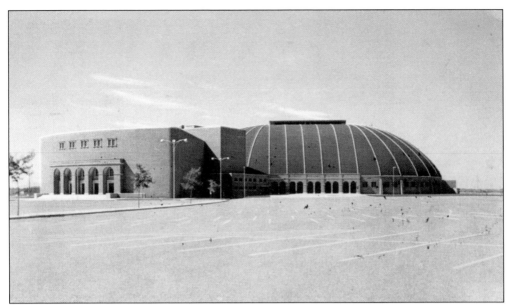

AUDITORIUM AND COLISEUM, LUBBOCK, TEXAS, C. 1958 (CURTEICHCOLOR—LUBBOCK NEWS AGENCY). Lubbock Municipal Coliseum was built in 1955 and opened in March 1956. Until the United Spirit Arena opened in 1998, it served as the home of the Texas Tech men's and women's basketball teams, as well as the primary venue in Lubbock for concerts and shows. The facility, now knows as City Bank Coliseum, has 6,904 permanent seats and room for 1,440 portable floor seats.

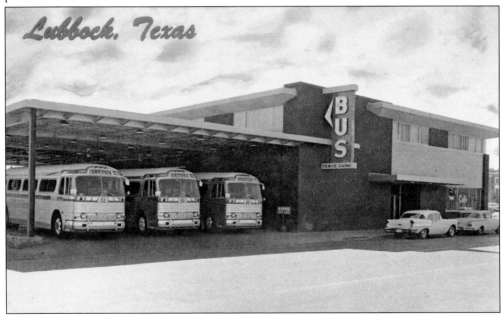

T.N.M.&O. COACHES, MODERN BUS STATION AND COFFEE SHOP, LUBBOCK, TEXAS, C. 1958 (BAXTER LANE COMPANY). This card reads, "Texas, New Mexico, and Oklahoma Coaches, Inc. serving Lubbock, Texas with 96 schedules daily, using all modern restroom and air conditioned equipped buses. Through service to all major cities in the great Southwest." Built in 1955, the building is located at Thirteenth Street and Avenue M.

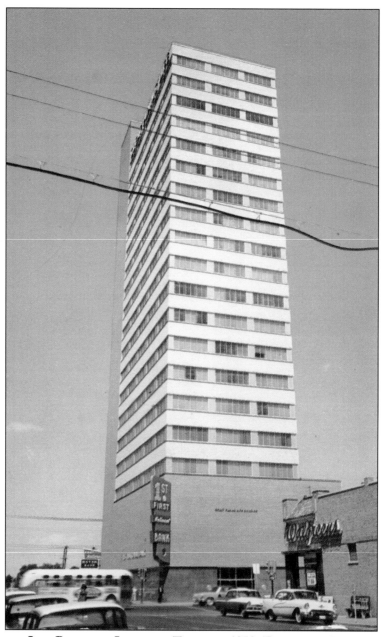

GREAT PLAINS LIFE BUILDING, LUBBOCK, TEXAS, C. 1958 (BAXTONE—LLOYD LANE). Built in 1955 and long known as one of Lubbock's most recognizable buildings, the Great Plains Life Building is a 20-story, 271-foot office building that is perhaps best known in Lubbock history for surviving the devastating tornado of May 11, 1970, even though it was so badly damaged that many thought the building would collapse. The building, at the corner of Broadway and Avenue L, had opened in 1955 with more than 110,000 square feet of office space and was billed as "the tallest building between Fort Worth and Denver" by local financiers. It was not until five years after the 1970 tornado that businesses began to reoccupy the building—renamed the Metro Tower—after Amarillo investors purchased the structure. The building is now home to the national headquarters of NTS Communications, who purchased the building in 1997.

Three

Downtown, Street, and Aerial Scenes

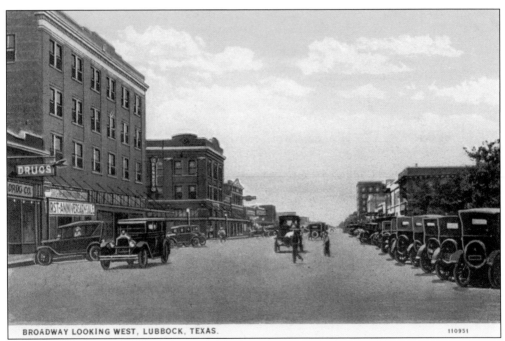

BROADWAY LOOKING WEST, LUBBOCK, TEXAS. 110951

Broadway Looking West, Lubbock, Texas, c. 1925 (C T American Art Colored).
This street scene of Broadway looking west shows the street without brick paving. The first brick roadways were built in 1920, and according to city records, one of the first four projects was Broadway from Avenue F west to Avenue K. This view is approximately from Avenue J and should show some brick paving.

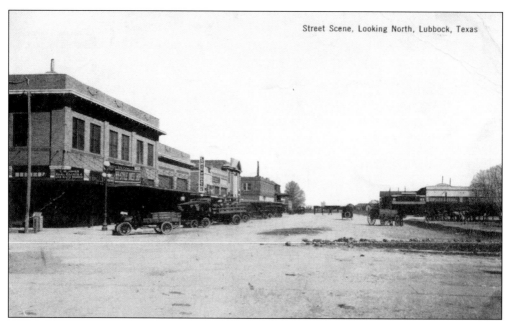

STREET SCENE LOOKING NORTH, LUBBOCK, TEXAS, 1918. This early photo postcard of a Lubbock Street scene appears to be taken looking north on Texas Avenue from the area of the downtown square. The card is postmarked 1918. A dress shop can be identified on the left and several types of vehicles, including buckboard wagons and various types of automobiles can be seen.

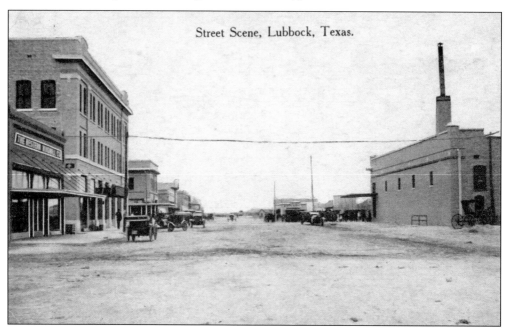

Street Scene, Lubbock, Texas.

STREET SCENE, LUBBOCK, TEXAS, 1916. This old photo postcard is postmarked 1916 and shows another Lubbock downtown street scene of the time. This appears to be Avenue J. The Western Windmill Company can be seen on the left. The most interesting part in this image is the covered buggy and what appears to be a large group of people waiting in line at the building on the left.

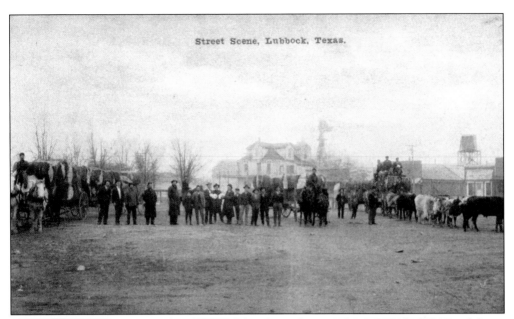

STREET SCENE, LUBBOCK, TEXAS, 1907. This colorized postcard is postmarked 1907 and shows a street scene from the square. The three-story Nicolett Hotel can be seen in the background. The men in the center foreground appear to be holding cotton, and the freight wagons to the right and left appear to be loaded with cotton bales.

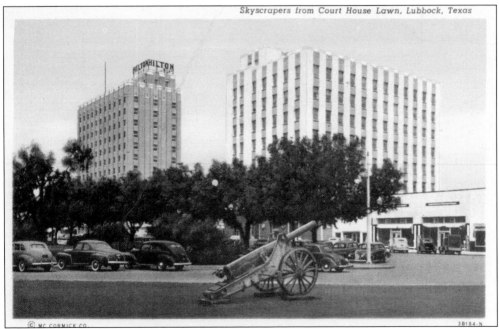

Skyscrapers from Court House Lawn, Lubbock, Texas

SKYSCRAPERS FROM COURTHOUSE LAWN, LUBBOCK, TEXAS, c. 1940 (CURTEICH). The view on this 1940 postcard is from the Lubbock County Courthouse, located on the main city square. The buildings seen in the background are the Hilton Hotel and the Lubbock National Bank Building. The card reads, "Lubbock, pop. 40,000, hub city of the fertile South Plains of Norwest Texas, also is the home of the fast-growing, 3,500 student Texas Technological College."

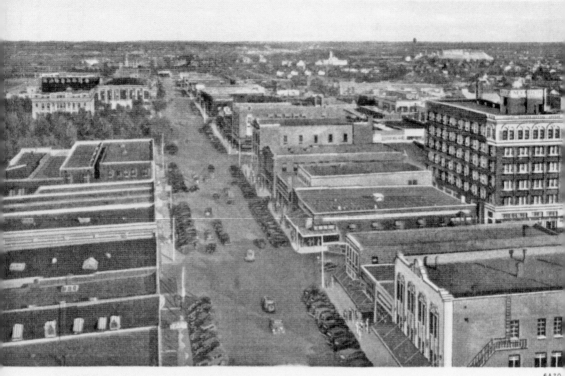

6A20

BROADWAY LOOKING EAST, LUBBOCK, TEXAS, C. 1935 (CURTEICH). This is a colorized postcard of Broadway looking east in the mid-1930s. During this time period, Broadway was the main business street in the city, as well as being the home to most of the large churches in the community. The building in the right front foreground is the Kress Building, located at 1109 Broadway. The Samuel H. Kress Company, a national retail corporation founded in 1896 and based in New York, already had 23 buildings across Texas when it took advantage of railway expansion into the South Plains and began plans for a Lubbock store in 1931. The building was completed in 1932, and the Kress Company operated the five-and-dime store until 1975. The building was added to the National Register of Historic Places in 1992. Goodwill Industries purchased the building and continues to use it for retail purposes.

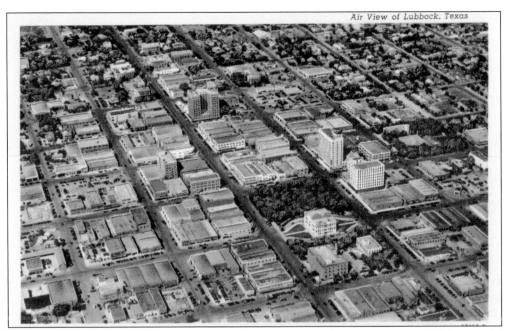

AERIAL VIEW OF LUBBOCK, TEXAS, *C.* 1940 (CURTEICH). This 1940-era postcard is an aerial view of the downtown area. Most distinguishable in the image is the Hotel Lubbock, located in approximately the upper center of the card. The Lubbock National Bank Building and the Hilton Hotel can also be noted in the right center of the card.

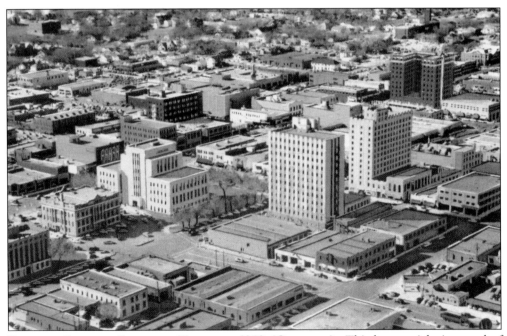

BUSINESS SECTION, LUBBOCK, TEXAS, *C.* 1950 (CURTEICH). This later aerial-view card of downtown Lubbock also notes the Hotel Lubbock, Lubbock National Bank, and the Hilton Hotel, but the Lubbock County Courthouse—the 1950 and the 1915 versions—can also be easily distinguished on the left side of this card.

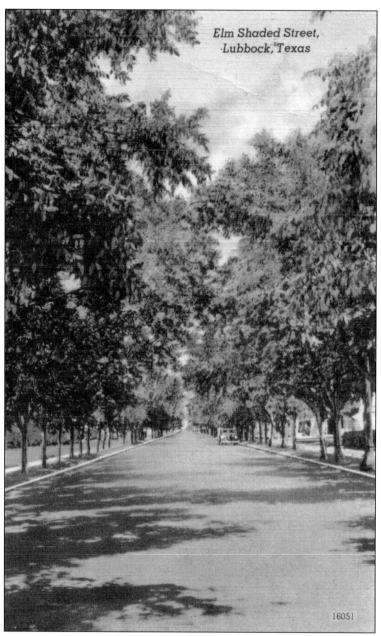

Elm Shaded Street,
Lubbock, Texas

16051

ELM SHADED STREET, LUBBOCK, TEXAS, 1944 ("COLOURPICTURE"—MARK HALSEY DRUG).
This image of a tree-lined street in Lubbock is most likely from the Overton area of town. In 1907, Dr. M. C. Overton established the Overton Addition, the first residential addition to the city. Dr. Overton hoped to develop a community with affordable land close to the downtown area. The addition was located on 640 acres between Fourth and Nineteenth Streets to the north and south and Avenue Q and University Avenue to the east and west. In the period between 1920 and the late 1940s, the area was home to many of Lubbock's most prominent families. When Texas Technological College was established in 1923, the addition became a natural bridge between the new college and the downtown area. Today the area has been named Overton Park through the renovation efforts of the McDougal Companies.

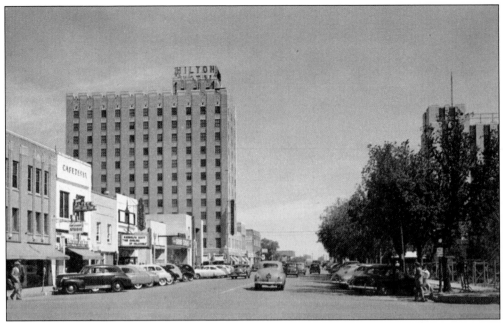

TEXAS AVENUE, LUBBOCK, TEXAS, C. 1950 ("DEXTONE"—HERALD PHOTOGRAPH). This card reads, "Looking North on Texas Avenue, this view includes the Hilton Hotel, some downtown stores, a portion of the county courthouse square, and beyond the trees, the Lubbock National Bank Building." Showing at the theater at the left is Randolph Scott in *The Doolins of Oklahoma*.

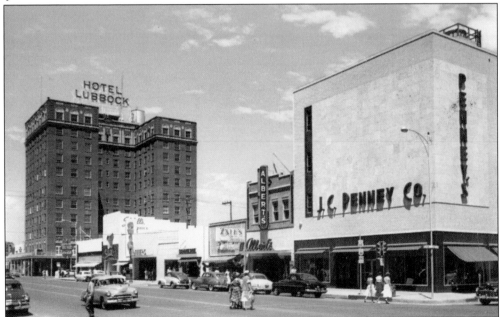

BROADWAY, LUBBOCK, TEXAS, C. 1952 ("DEXTONE"—HERALD PHOTOGRAPH). This 1954 card reads, "Looking west on Broadway, this view shows some of the shopping area of downtown Lubbock, Texas, and the centrally located Hotel Lubbock." This card was never mailed, but the message says, "This is a small part of Lubbock. It is a large city, its population is 136,524."

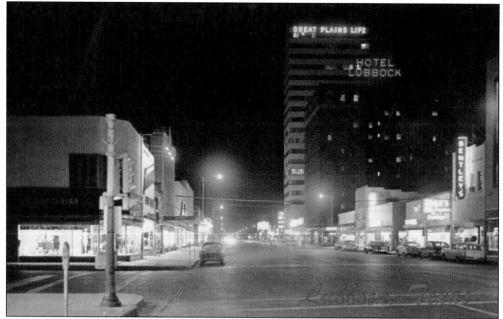

LUBBOCK, TEXAS, C. 1956 (BAXTER LANE—AMARILLO). This 1956 card reads, "Night view of Broadway Street, looking west in downtown. Lubbock is the third largest inland cotton market in the nation. It is the home of Texas Tech, second largest state college. Lubbock boosts a population of over 150,000 and is growing at a very rapid pace." Seen in this view are the Hotel Lubbock and the newly constructed Great Plains Life Building.

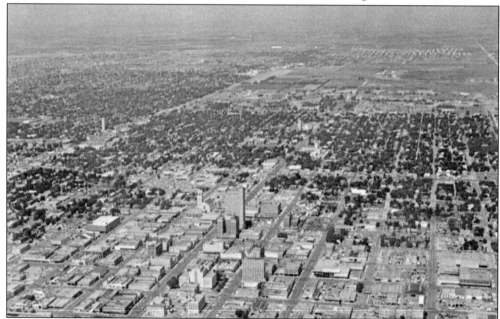

AERIAL VIEW OF LUBBOCK, TEXAS, C. 1960. This great aerial shot of the city of Lubbock is actually a business card for a realtor from J. W. Chapman and Sons. In this shot, one can see the landmarks of the Hotel Lubbock and the Great Plains Life Building, as well as the major churches on Broadway and the spacious Texas Tech campus.

Four

TEXAS TECH

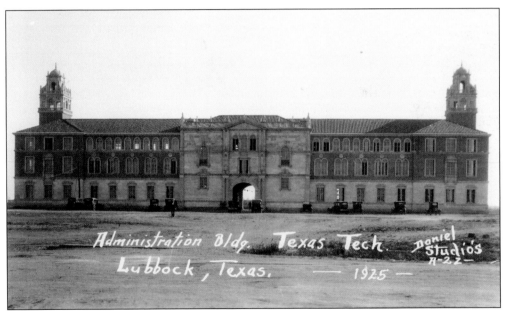

ADMINISTRATION BUILDING, TEXAS TECHNOLOGICAL COLLEGE, LUBBOCK, TEXAS, 1925 (DANIEL STUDIOS). The first building constructed on campus and the most recognizable, the Administration Building was completed in 1925. Construction began in November 1924, when the cornerstone was laid in front of a crowd of 20,000 people. Texas Technological College opened for classes on October 1, 1925, and was composed of four schools—agriculture, engineering, home economics, and liberal arts—with a total first enrollment of 914 students.

LUBBOCK WINS TECH ON THE FIRST BALLOT

Locating Committee Went into Executive Session in the Texas Hotel at Fort Worth at Nine O'clock and after Five Hours Deliberation Unanimously Designated Lubbock as the Official Location for the Technological College

Special to the Avalanche

Fort Worth, August 8—Lubbock was Unanimous Choice of the Locating Board for the Texas Technological College on the First Ballot at the five hour Session of the Board here today. The Decision was made following a six months study of the briefs of the 35 applicant towns and a three weeks tour of inspection of the territory. At 1:42 o'clock Wednesday afternoon one of the members of the Board whose name was not divulged moved that a ballot be taken and his motion prevailed. The roll was then called and every member voted for Lubbock. The Board had been in session practically continuous since 9:00 o'clock Wednesday morning and during that time various other towns were discussed.

LUBBOCK WINS TECH ON FIRST BALLOT, 1923. On February 10, 1923, Gov. Pat Neff signed the legislation creating Texas Technological College. In July, a committee began searching for a site for the new West Texas college. When the members of the committee visited Lubbock, they were overwhelmed to find residents lining the streets to show support for the idea of hosting the institution. The local newspaper during the committee visit ran numerous advertisements from nearby towns urging the members of the committee to select Lubbock as the home of the new college. That August, Lubbock was chosen on the first ballot over other area towns, including Floydada, Plainview, and Sweetwater. The Lubbock Chamber of Commerce sponsored a massive barbecue August 28, 1923, that drew some 30,000 visitors, including Governor Neff. Just more than a year later, a cornerstone ceremony was held for the Administration Building, drawing another overflow crowd. (Courtesy of the *Lubbock Avalanche-Journal*.)

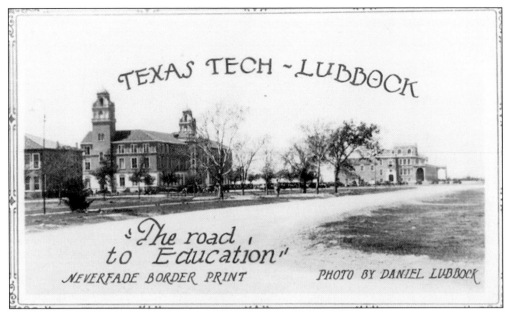

TEXAS TECH, LUBBOCK, THE ROAD TO EDUCATION, 1935 (DANIEL STUDIOS). This great image of the main part of the Texas Tech campus shows the Administration Building with the east wing, the new Chemistry Building to the west, and the men's dormitory Doak Hall in the left foreground. The area just out of the image to the right would become Memorial Circle.

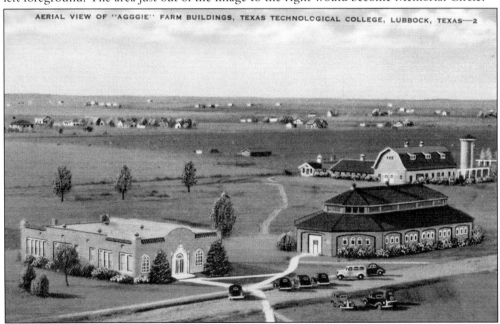

AERIAL VIEW OF "AGGIE" FARM BUILDINGS, TEXAS TECHNOLOGICAL COLLEGE, LUBBOCK, TEXAS, c. 1941 (E. C. CROPP). This card states, "There are 320 acres in the Texas Technological College campus proper, with 1,668 acres additional used as farm land by the Division of Agriculture. Value of animals and implements used by agricultural students is $22,000." Shown are the Agriculture Building, the Livestock Pavilion, and the Dairy Barn. The Livestock Pavilion and the Dairy Barn were both original buildings on campus that were completed in 1925.

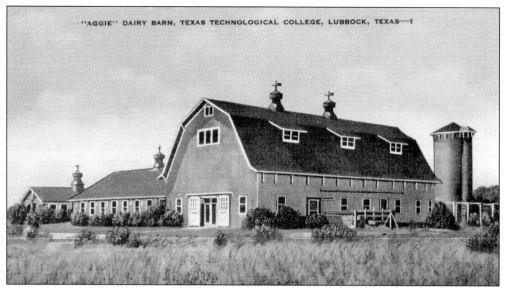

"AGGIE" DAIRY BARN, TEXAS TECHNOLOGICAL COLLEGE, LUBBOCK, TEXAS, C. 1941 (E. C. CROPP). Part of this card states, "The 'Aggie' Dairy Barn is the center of interest for dairy manufacturing. It is used as a headquarters for the Tech Student Dairy Association." Students would bring their own cows to campus and market their own milk products through the Student Dairy Association. After 1927, the agriculture department sold milk and ice cream to Lubbock residents and college cafeterias.

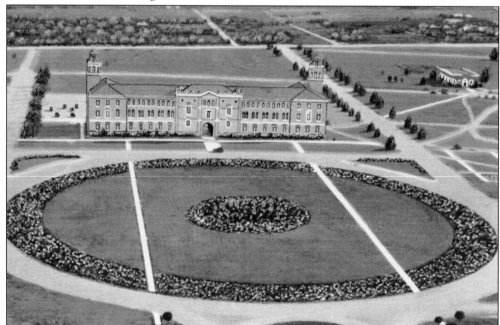

AERIAL VIEW OF ADMINISTRATION BUILDING, TEXAS TECHNOLOGICAL COLLEGE, LUBBOCK, TEXAS, C. 1941 (E. C. CROPP). This postcard of the Administration Building gives an aerial view of Memorial Circle. To the left of this perspective is the main entrance to the university. To the right is the Science Quadrangle, and below the view of the card is the Engineering Quadrangle. The street at the top of the card is Nineteenth Street.

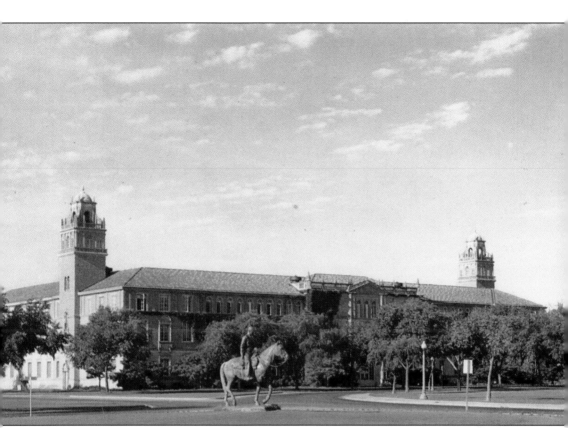

ADMINISTRATION BUILDING, TEXAS TECHNOLOGICAL COLLEGE, LUBBOCK, TEXAS, C. 1960 (DEXTER PRESS—HERALD PHOTOGRAPH). This more modern view of the Administration Building is a great example of the Spanish Renaissance style that had been utilized with most campus buildings. The "Victory Bells," one large and one small with the combined weight of 1,200 pounds, hang in the east tower of the Administration Building. The class of 1936 gave the Victory Bells as its gift to the school. They rang for the first time at the group's graduation. Today they are rung for 30 minutes after athletic victories and other special occasions. The Administration Bell Towers are images that are frequently associated with Texas Tech, as well as the statue of Will Rogers on his horse, Soapsuds, which can also be seen in this view. The wrapping of the statue in red streamers before each home football game is done by the Saddle Tramps, an all-male service organization at the school. The Saddle Tramps are also the group that rings the Victory Bells after each athletic win.

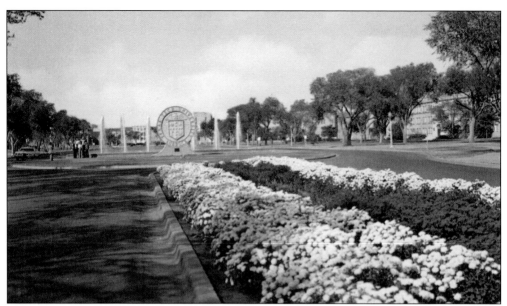

ENTRANCE MARKER, TEXAS TECHNOLOGICAL COLLEGE, LUBBOCK, TEXAS, C. 1968
(ARMSTRONG'S WESTERN FOTOCOLOR POSTCARD PHOTOGRAPHERS—FORT WORTH, TEXAS).
This postcard of the main entrance to campus states, "A seven-jet fountain provides a sparkling
background to the handsome stone replica of the Texas Tech University seal at the Broadway
and University Avenue entrance to the campus. Carved in sunset-red granite, the imposing
marker is two feet thick, twelve feet in diameter and weighs 37,500 pounds."

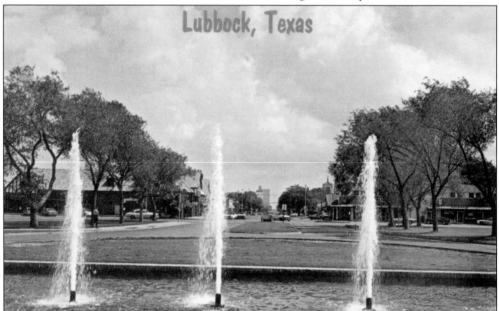

LUBBOCK, TEXAS, C. 1960 (BAXTER LANE—AMARILLO). This is a view looking east on
Broadway from the fountain at the main entrance of Texas Tech. This photograph was taken
prior to the placement of the bed of mums in front of the fountain, as seen in the above image.
In the background looking down Broadway, the steeple of the First Baptist Church can be seen
on the right, and the Great Plains Life Building can be seen on the left.

40

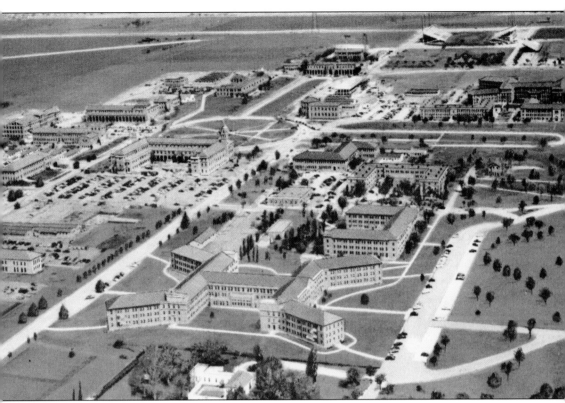

AERIAL VIEW, TEXAS TECHNOLOGICAL COLLEGE, LUBBOCK, TEXAS, POSTMARKED 1955 (CURTEICH). This great aerial shot of the Texas Tech campus in the early 1950s gives the viewer a great perspective on the size of the campus and the development of the school over its first 30 years. The street at the top of the card is Fourth Street, which is where one can see Jones Stadium, home to Texas Tech football. At the top center is the Engineering Quadrangle, which drops down to Memorial Circle, the museum, West Hall, Snead Hall, Gordon Hall/ Bledsoe Hall, the Administration Building, and the Science Quadrangle. At center in front is the dormitory complex of Horn Hall/Knapp Hall, as well as Drane Hall and Doak Hall/Weeks Hall. On the left are the Music Building, the Student Union, and the Agriculture Building. A number of campus buildings are not in this view, as they would be to the left and bottom of this campus shot. This card is an excellent example of how much the campus has grown from the single Administration Building in 1925.

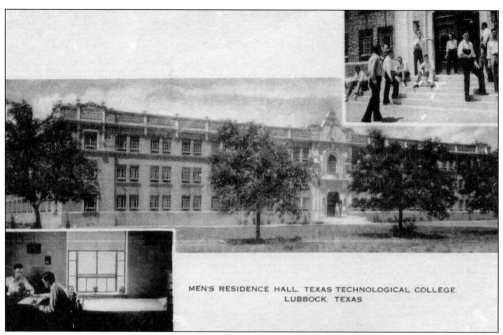

MEN'S RESIDENCE HALL. TEXAS TECHNOLOGICAL COLLEGE.
LUBBOCK. TEXAS

MEN'S RESIDENCE HALL, TEXAS TECHNOLOGICAL COLLEGE, 1940s (ABOVE, ARTVUE; BELOW, COLOURPICTURE—MARK HALSEY DRUG). These two cards are images of West Hall on the Texas Tech campus. West Hall was built in 1934 and was used as a men's residence hall. Today it is home to the Visitors Center, Admissions Office, and the Student Financial Center. The Registrar's Office is located in the center and in the west wing of the first floor of West Hall. The card above shows a typical dorm room, as well as students gathered on the front steps. The card below is a colorized image of the front of West Hall showing the landscaping and the architecture style of the building.

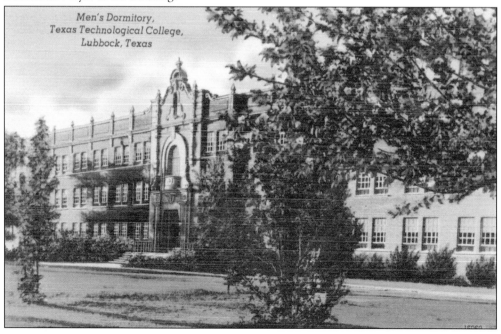

Men's Dormitory,
Texas Technological College,
Lubbock, Texas

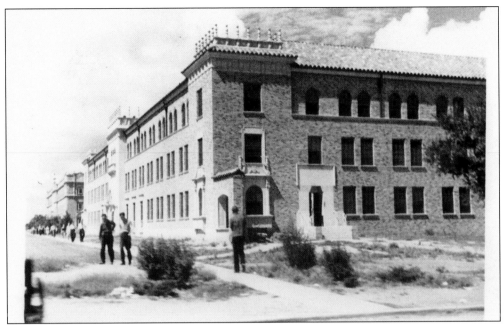

SNEED HALL, TEXAS TECHNOLOGICAL COLLEGE, LUBBOCK, TEXAS, C. 1941. This original photograph is of Sneed Hall on the Texas Tech campus. On the reverse of this photograph is written "September 16, 1941—Texas Tech Lubbock—Sneed Hall." Sneed Hall was built in 1938 and was used as a men's dormitory. When one enters the campus from the main Broadway entrance, Sneed is the first building to the north.

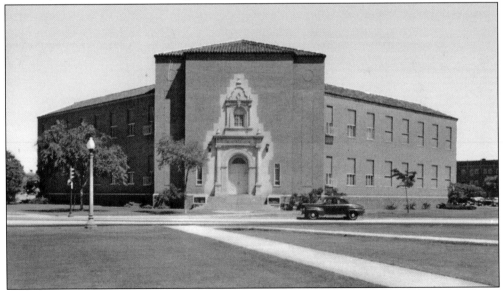

MUSEUM, TEXAS TECHNOLOGICAL COLLEGE, LUBBOCK, TEXAS, C. 1948 (CURTEICH). At the northeast potion of the circle was the location of this building, the original Texas Tech Museum. In 1935, William Curry Holden, a history and anthropology instructor at the school, organized the West Texas Museum Association and became the first director of the Texas Tech Museum. When the new museum was dedicated in 1970, the original museum was renamed Holden Hall and housed social sciences and the graduate school.

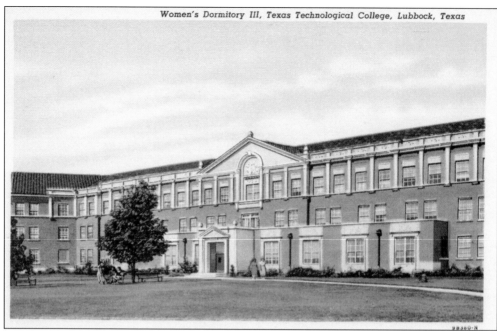

Women's Dormitory III, Texas Technological College, Lubbock, Texas

WOMEN'S DORMITORIES, TEXAS TECHNOLOGICAL COLLEGE (ABOVE, CURTEICH, 1948; BELOW, DEXTONE, 1954). These two postcards show views of Horn Hall, built in 1948 and referred to initially as "Girls Dorm III." Most of the residence halls at Texas Tech were constructed as complexes, with a women's dormitory on one side and a men's dormitory on the other side. However, the Horn/Knapp complex does not follow this pattern, as the west side of Horn Hall, Knapp Hall, is also a women's dormitory. The residence complex has a capacity of 674 female students. Horn/Knapp Complex for women is located on the east side of campus close to the Student Union, Music Building, and the Sports Science Building. Today the complex caters to female students in the science and engineering fields of study.

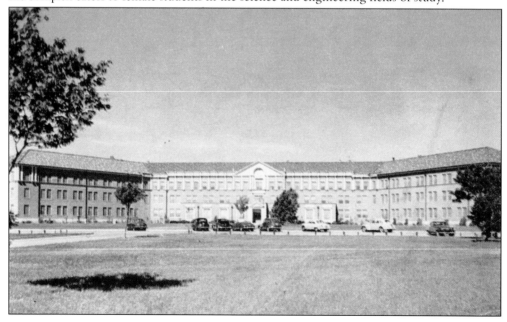

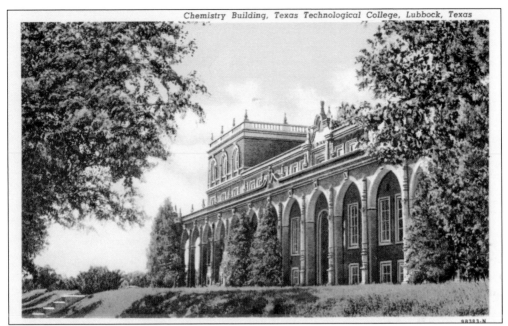

CHEMISTRY BUILDING, TEXAS TECHNOLOGICAL COLLEGE, LUBBOCK, TEXAS, c. 1948 (CURTEICH). The Chemistry/Science Building at Texas Tech was opened on January 1, 1929. The original two-story Chemistry Building was 240 feet long and 60 feet wide, with one wing extending back 100 feet. Although designed primarily as a chemistry building, it originally housed the Departments of Biology, Geology, Physics, and Chemistry. In October 1968, a new addition was made to the building with an additional 125,000 square feet and auditorium.

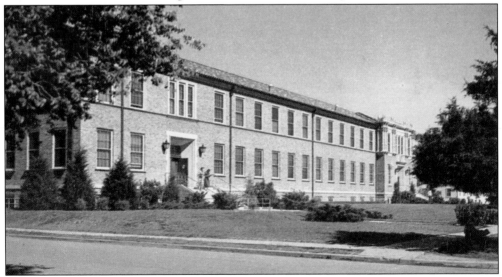

AGRICULTURE BUILDING, TEXAS TECHNOLOGICAL COLLEGE, LUBBOCK, TEXAS, c. 1954 (DEXTONE—HERALD PRESS). The back of this card states, "Boasting the largest single campus in the world, 2,180 acres, Tech uses 350 acres for buildings, streets, and parking areas and lawns and 1,830 acres for agricultural development, training and research work." Strong programs of study in agricultural sciences and natural resources have been the tradition at Texas Tech since it was started in 1925. This building was completed in 1928.

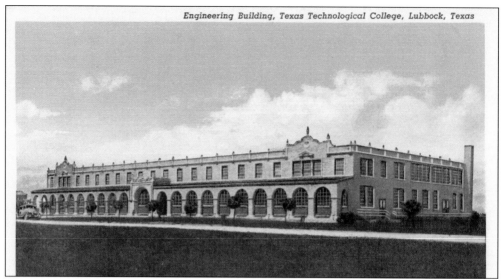

ENGINEERING BUILDING, TEXAS TECHNOLOGICAL COLLEGE, LUBBOCK, TEXAS, c. 1948 (CURTEICH). Texas Technological College's School of Engineering was created in the fall of 1925. It began with 313 students enrolled, and there were only two faculty members, Dean William J. Miller and Prof. Edmond Weymond Camp. Originally, the Textile Engineering Building, now the Industrial Engineering Building, housed all classes. The Engineering Building seen on this card was built in 1928 and is now the Electrical and Computer Engineering Building.

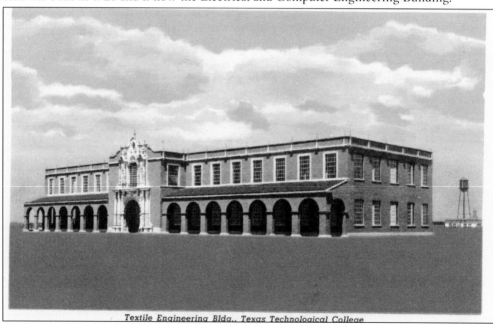

Textile Engineering Bldg., Texas Technological College

TEXTILE ENGINEERING BUILDING, TEXAS TECHNOLOGICAL COLLEGE, c. 1948 (CURTEICH). The Textile Engineering Building was the original Engineering Building on campus and housed all engineering classes until the West Engineering Building, seen in the card above, was completed in 1928. By 1933, the school's civil, electrical, industrial, mechanical, and textile engineering programs were accredited by the Engineering Council for Professional Development. Today the College of Engineering is known as the Edward E. Whitacre Jr. College of Engineering.

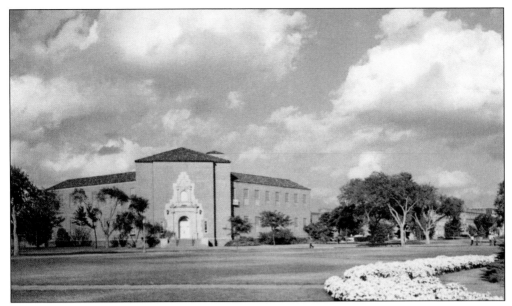

HOLDEN HALL, TEXAS TECH UNIVERSITY, c. 1976 (ARMSTRONG'S WESTERN FOTOCOLOR POSTCARD PHOTOGRAPHERS—FORT WORTH, TEXAS). Originally the university museum, Holden Hall became the Social Sciences Building in 1975. The Peter Hurd murals in the rotunda of Holden Hall are a popular attraction for visitors. Holden Hall houses classrooms and offices for arts and sciences, the graduate school, and the Departments of History, Anthropology, Economics, and Geography.

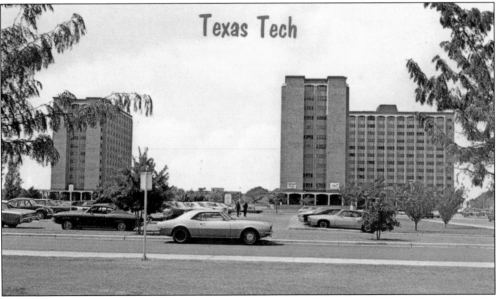

WIGGINS COMPLEX, LUBBOCK, TEXAS, c. 1976 (BAXTER LANE—AMARILLO). The caption for this card is "the Wiggins Complex at Texas Tech University consists of three, twelve-story residence halls, each housing 572 students with dining facilities designed to feed 3,432 students." On the left is Coleman Hall, and on the right is the Chitwood/Weymouth Complex. The three buildings were completed for residency for the fall semester of 1969. The complex was named after Texas Tech president Dossie M. Wiggins (1948–1952).

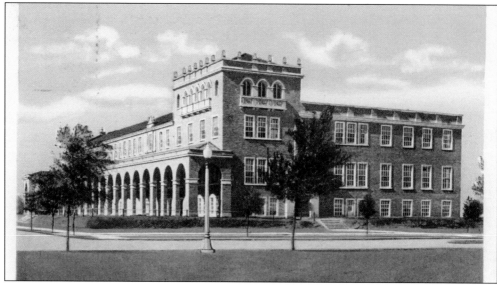

LIBRARY, TEXAS TECHNOLOGICAL COLLEGE (ABOVE, CURTEICH, 1948; BELOW, ARMSTRONG FOTOCOLOR, 1974). Clifford B. Jones donated the first books for the library in 1924, and the school's first librarian, Elizabeth Howard West, was hired in May 1925. The image above is a postcard of the original Texas Tech Library, which was located on the north side of the current Science Quadrangle in 1938. This building later was the Social Sciences Building and home to the Southwest Collection, and later still it became the Mathematics and Statistics Building, which is its use today. The image below is a postcard of the current library, which opened in 1962, with an expansion being added in the 1970s. The library book collection includes over 1.7 million volumes ranging from scholarly to popular works. The Texas Tech Library System now includes the Law Library, the Southwest Collection, the Vietnam Archive, the Architecture Library, and the Health Sciences Center Library.

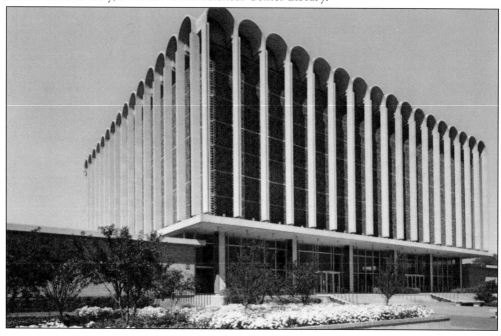

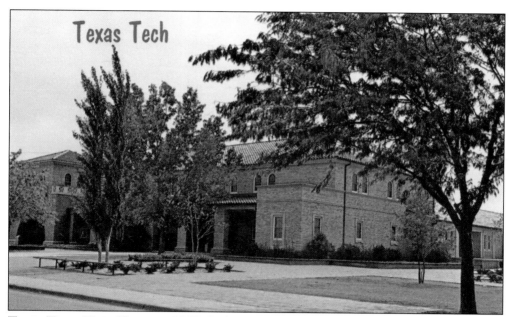

TEXAS TECH, TECH UNION, C. 1968 (BAXTER LANE—AMARILLO). Work began on the Union Building in 1944. Over the years, the center has been called the Tech Union, Student Union, University Center, UC, Recreation Center, and the SUB. Additions were made between 1959 and 1960 and again between 2001 and 2006. This center serves for leisure time activities of the students and staff of the university, with meeting rooms, ballrooms, snack bars, shops, lounge areas, and game areas. Today the University Bookstore is also part of the building.

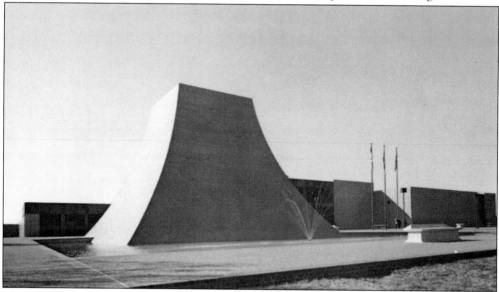

MUSEUM-PLANETARIUM, TEXAS TECH UNIVERSITY, LUBBOCK, TEXAS, C. 1976 (ARMSTRONG'S WESTERN FOTOCOLOR POSTCARD PHOTOGRAPHERS—FORT WORTH, TEXAS). This postcard depicts the Texas Tech Museum and Moody Planetarium. This building was opened in 1970 and today includes the museum, the Diamond M. Gallery, the Helen DeVitt Jones Auditorium and Sculpture Court, Moody Planetarium, the Natural Science Research Laboratory, and the Lubbock Lake Landmark.

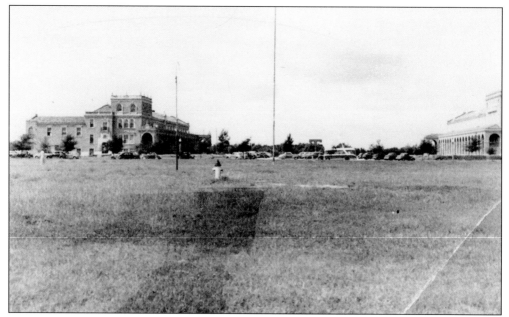

SCIENCE QUAD AND MEMORIAL CIRCLE, 1941. This snapshot shows the Chemistry Building, the library, and a large flagpole that was to become Memorial Circle. In the center of the parking area, one can see the famous "Double T" neon sign, donated by the class of 1938, which is now affixed to the east side of Jones AT&T Stadium. It was reputedly the largest neon sign in existence at the time it was given to the college.

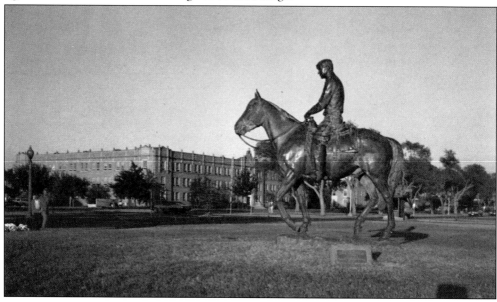

WILL ROGERS STATUE, TEXAS TECH UNIVERSITY, C. 1974 (ARMSTRONG'S WESTERN FOTOCOLOR POSTCARD PHOTOGRAPHERS—FORT WORTH, TEXAS). One of the most well-known landmarks on campus is the statue of Will Rogers and his horse Soapsuds. This memorial was dedicated on February 16, 1950. The statue was placed so the horse's posterior was facing in the direction of Texas A&M, one of the school's rivals. Before every home football game the Saddle Tramps wrap "Old Will" with red crepe paper.

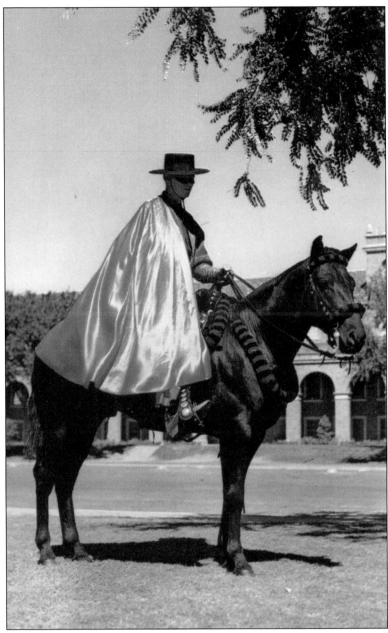

MASKED RIDER, TEXAS TECH UNIVERSITY, c. 1968 (BAXTONE). The Masked Rider is the oldest and most popular of Texas Tech mascots. Originally started in 1936 as a dare, the rider was called the "Ghost Rider" because no one knew his identity. The ghost riders would circle the football field at home games and then disappear. At the 1954 Gator Bowl, Joe Kirk Fulton led the Texas Tech team onto the field mounted on a black horse and dressed in red shirt and black cape, and the tradition of the Masked Rider began. Ed Danforth, a writer for the *Atlanta Journal* and a press box spectator, later wrote, "No team in any bowl game ever made a more sensational entrance. The Masked Rider has led the team onto the field with 'Guns Up' at all home football games since 1954. It is said to be the nation's first school mascot featuring a live horse at football games."

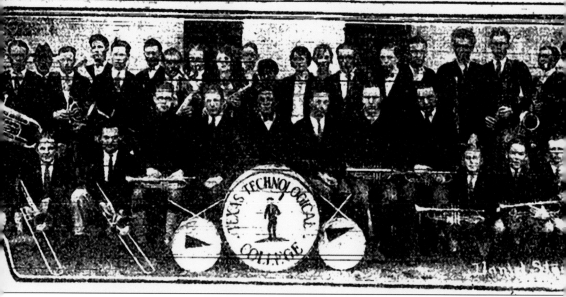

TEXAS TECHNOLOGICAL COLLEGE BAND, 1926. The Tech band performed at the very first Texas Tech football game in October 1925 under the direction of W. Waghorne, Tech's first music department chairman. This image from the June 12, 1926, edition of the *Lubbock Morning Avalanche* shows the original Texas Technological College Band. The band director, hired in 1926, was Harry Lemaire, a former British army officer and veteran of the Spanish-American War, where he served as Teddy Roosevelt's bandmaster in the San Juan Hill campaign. He was also friend to famed band director John Philip Sousa, who visited him in Lubbock on several occasions. The size of the band grew from 100 in 1959 to 450 in 1981. Today the band is known as the "Goin' Band from Raiderland" and is known as the first band to have travelled extensively in support of its football team, the fist band to have had its halftime show broadcast over the radio, and the first band to allow women to participate extensively. (Courtesy of the *Lubbock Avalanche-Journal*.)

Five

PLANES, TRAINS, AND AUTOMOBILES

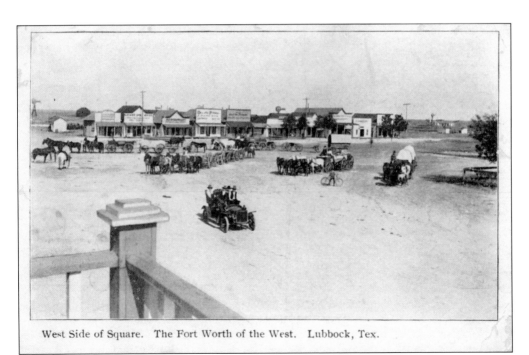

West Side of Square. The Fort Worth of the West. Lubbock, Tex.

WEST SIDE OF SQUARE, THE FORT WORTH OF THE WEST LUBBOCK, TEXAS, 1909 (GARTNER AND BENDER). This postcard is from the time that the city of Lubbock incorporated. A wide variety of transportation can be seen in the postcard, taken from the balcony of the Nicolett Hotel of the west side of the square, including horses, wagons, buckboards, a buggy, an automobile, and a bicycle.

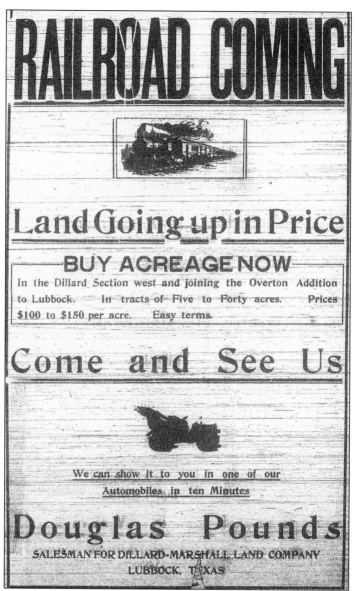

RAILROAD COMING

Land Going up in Price

BUY ACREAGE NOW

In the Dillard Section west and joining the Overton Addition to Lubbock. In tracts of Five to Forty acres. Prices $100 to $150 per acre. Easy terms.

Come and See Us

We can show it to you in one of our Automobiles in ten Minutes

Douglas Pounds

SALESMAN FOR DILLARD-MARSHALL LAND COMPANY
LUBBOCK, TEXAS

Lubbock Morning Avalanche, **1909.** The *Morning Avalanche* newspaper, in its January 29, 1909, edition—roughly six weeks before the city was incorporated—trumpeted the fact that a deal had been signed with the Santa Fe Railway. Construction was to begin on May 1, 1909, and the land companies began immediately to run advertisements in the paper for the expected growth of the city and rise in land prices. Here is one such advertisement from the *Morning Avalanche* in 1909. The first railroad line was built south from Plainview to Lubbock, and a grand celebration greeted the first train when it steamed into town on September 25, 1909. The population of Lubbock boomed from 1,000 to 4,100 during the railroad expansion. By 1928, Lubbock saw the opening of the Fort Worth and Denver South Plains Railway, a subsidiary of Burlington Northern, from Estelline southwestward to Lubbock. By then, Lubbock's future as the "Hub City" was secure. It had been selected as the site of the new Texas Technological College, and the county's population in 1930 had ballooned to almost 40,000. (Courtesy of the *Lubbock Avalanche-Journal*.)

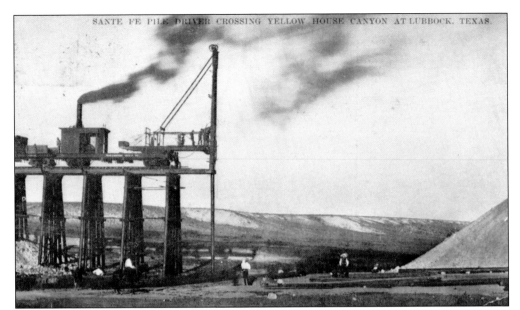

SANTA FE BRIDGE OVER YELLOW HOUSE CANYON, LUBBOCK, TEXAS (PALACE PHARMACY, LUBBOCK, TEXAS: ABOVE, 1910; BELOW, 1914). Yellow House Canyon is a major landmark on the Texas South Plains and cuts a gap of more than 35 miles into the eastern edge of the Caprock escarpment in Lubbock and Crosby Counties. When the Santa Fe Railroad extended its route to Lubbock in 1909, one of the major hurdles to overcome was bridging the canyon. These two postcards from 1910 and 1914 show the railroad pile driver building the bridge across the Yellow House Draw. The towns of Ransom Canyon Village and Slaton, both in southeast Lubbock County, are located in or near the canyon. Buffalo Springs Lake occupies land near Ransom Canyon in southeastern Lubbock County. Interesting to note is the misspelling of Santa Fe on the cards.

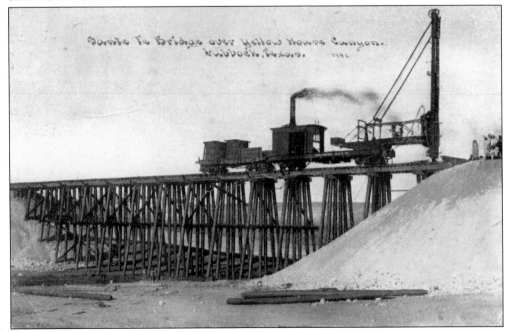

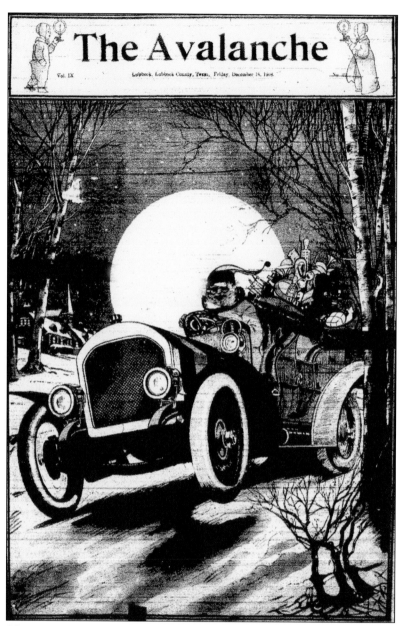

LUBBOCK MORNING AVALANCHE, DECEMBER 16, 1908. Dr. M. C. Overton, Lubbock's only physician in the very early days before the city incorporated, made house calls by horse and buggy until 1908, when he bought the first privately owned automobile in Lubbock. Overton managed to stay in touch with his office while on rounds. The doctor carried a phone receiver with him that had a long wire attached to it. When he came to an overhead phone line, he would throw the wire across it so that he could contact the operator and check in with his office. The first production Model T was produced on August 12, 1908, and several had arrived in Lubbock before the end of the year. This front page from the December 16, 1908, Morning Avalanche shows Santa Claus heading into Lubbock in his automobile. Automobiles appear to have been popular in early Lubbock, as many photographs from this period depict a variety of automobiles. (Courtesy of the Lubbock Avalanche-Journal.)

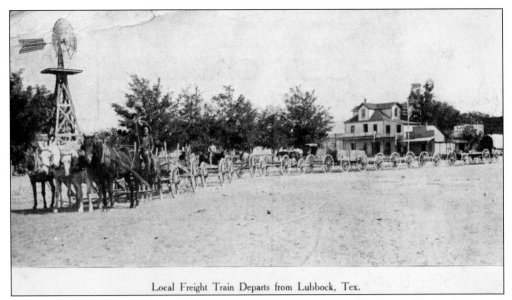

Local Freight Train Departs from Lubbock, Tex.

LOCAL FREIGHT TRAIN DEPARTS FROM LUBBOCK, TEXAS, 1908 (STAR DRUG COMPANY SERIES). Before the Santa Fe Railroad came to town, freight to and from Lubbock was moved by wagon train, just like the "freight train" pictured on this 1908 real photo postcard. The large building in the background is the Nicolett Hotel. During this time period, prior to the railroad in Lubbock, Plainview was the last rail point, and materials had to be hauled by freight wagon to Lubbock from Plainview.

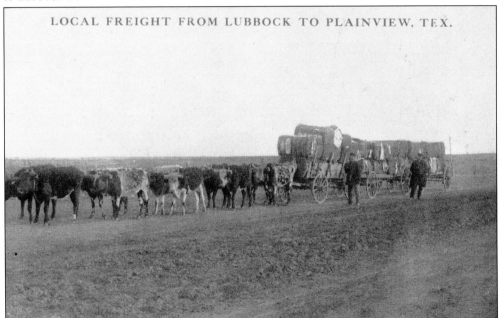

LOCAL FREIGHT FROM LUBBOCK TO PLAINVIEW, TEX.

LOCAL FREIGHT FROM LUBBOCK TO PLAINVIEW, 1911. This is another real photo postcard that shows a freight train of wagons from Lubbock to Plainview. This train is a load of cotton bales that is being pulled by oxen. Although this card is postmarked 1911—after the railroad came to Lubbock—it was most likely produced prior to the 1909 arrival of Santa Fe Railroad in Lubbock.

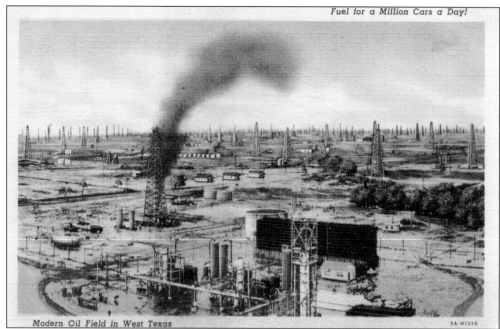

Fuel for a Million Cars a Day!

Modern Oil Field in West Texas

5A-H1010

MODERN OIL FIELD, NEAR LUBBOCK, TEXAS, 1939 (CURT TEICH—MCCORMICK, AMARILLO).
In West Texas, oil and gas activity diversified the regional economy, as it had already done in other sections of the state. This 1939 postcard is most likely of the Slaughter field, a 100,000-acre oil and gas producing area in Hockley, Cochran, and Terry Counties. The card states, "Fuel for a million cars a day!" The 1955 Pictorial Map of Lubbock states that the Lubbock area contains approximately 41,000 oil producing wells.

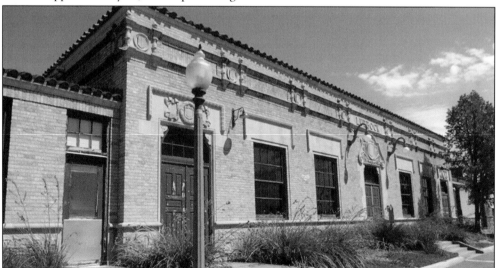

THE FORT WORTH AND DENVER RAILROAD DEPOT. The Fort Worth and Denver South Plains Railway Depot, located at 1801 Crickets Avenue, was built in the Spanish Renaissance Revival style in 1928. Completion of the railway to Lubbock in 1928 provided the city with a second major rail connection and an expanded trade area. The depot was abandoned in 1953 and was adapted for a restaurant in 1976, giving rise to the famous Depot District. It now houses the Buddy Holly Center. (Courtesy of the *Lubbock Avalanche-Journal*.)

58

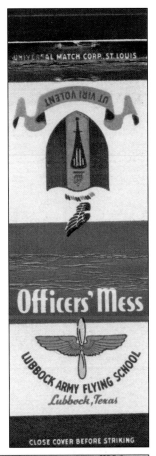

LUBBOCK ARMY FLYING SCHOOL, 1943 (RIGHT, UNIVERSAL MATCH COMPANY; BELOW, CURT TEICH—U.S. ARMY AIR CORPS). In February 1942, the Lubbock Army Flying School opened, and almost immediately, the base began training military pilots for their roles in World War II. The early pilot classes became experts in handling a number of aircraft, including models such as the North American AT-6 Texan, the Curtiss AT-9 Jeep, and the Beechcraft AT-10 Wichita, some of which are shown in the Army Air Corps card pictured below. The facility, which was renamed Lubbock Army Air Field on April 26, 1943, closed just more than two years later, having trained 7,008 bomber, fighter, and transport pilots for the war effort. Pictured at right is a matchbook cover from the officer's mess of the base. The base closed in 1945 but reopened in 1949 as Reese Air Force Base.

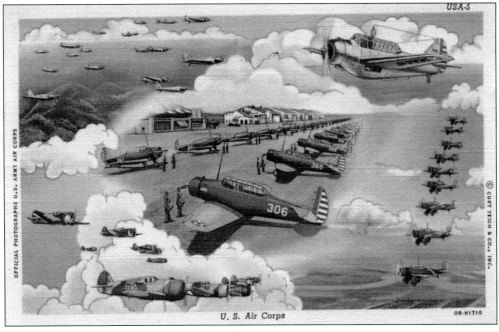

U. S. Air Corps

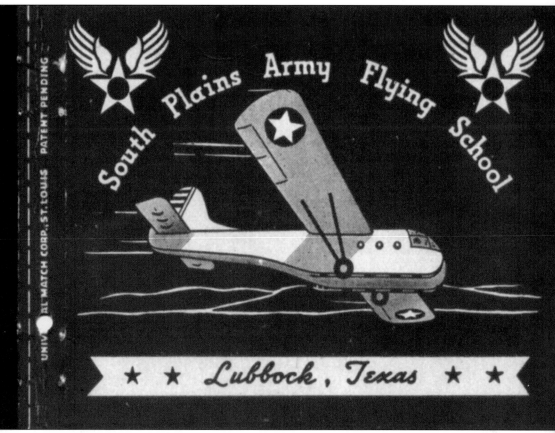

SOUTH PLAINS ARMY FLYING SCHOOL, 1943 (UNIVERSAL MATCH COMPANY). Also during World War II, Lubbock's municipal airport became the South Plains Army Air Field, which was were several thousand glider pilots received their training. While the Lubbock Army Flying School trained pilots on twin-engine aircraft, the South Plains facility was home to the advanced glider school. The glider training program was instrumental to the war effort, as the engineless planes were used in major campaigns throughout Europe, including the invasion of Normandy, as well as several campaigns in Burma. The gliders were capable of carrying 13 fully armed troops in addition to a pilot and copilot. Likewise, they could transport howitzers, jeeps, and munitions. The contributions of glider pilots are recognized at the Silent Wings Museum, which opened in 2002 in the original Terminal Building of Lubbock International Airport.

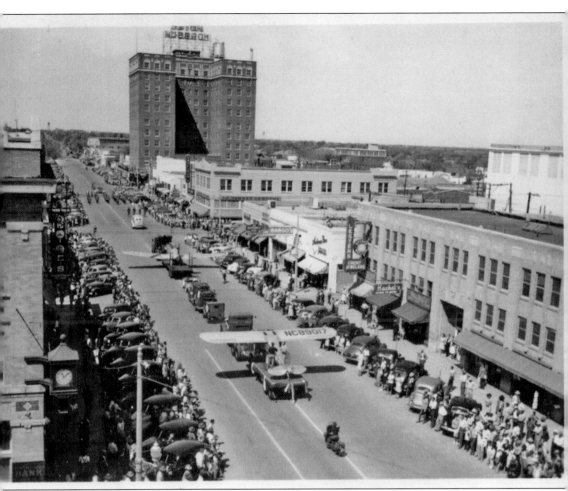

MILITARY PARADE DOWN BROADWAY, 1943. The South Plains Army Airfield's mission was to train combat glider pilots. These combat gliders were designed to carry soldiers, small jeeps, cannons, or other supplies quickly and quietly into the heat of battle. These "silent wings" were used extensively in the D-Day invasion to free Europe and also in many Pacific theater operations. The South Plains Army Airfield grew to be the largest glider training facility in the world. The vast majority of the glider pilots earned their wings at this airfield. However, the glider program was suspended shortly after the war, and the base was officially closed on April 1, 1945, according to the Silent Wings Museum. Pictured here is an original photograph from 1943 that shows a parade of aircraft, equipment, and personnel from the airfield traveling down Broadway as the streets are lined with Lubbock citizens. Hotel Lubbock can be seen in the background.

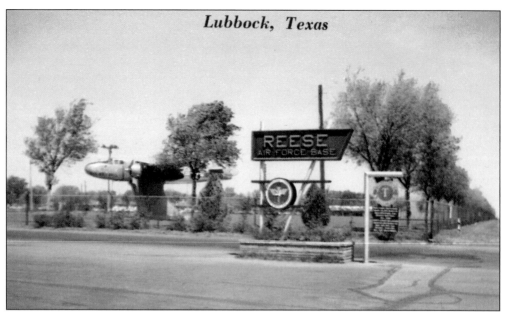

REESE AIR FORCE BASE (BOTH, BAXTONE). Although deactivated in 1945, the South Plains Army Flying School was reactivated in August 1949 to train pilots. In October 1949, the city was informed that the facility would officially be renamed Reese Air Force Base in honor of 1st Lt. Augustus F. Reese Jr., a Shallowater native who was killed in 1943 while flying a voluntary combat mission over Italy. In 1950, Reese Air Force Base was named a permanent installation and became a training ground for some of the best military pilots. The base officially closed on October 1, 1997, having trained more than 25,000 pilots, including, for a short while, Reza Pahlavi, the crown prince of Iran. The card above shows the entrance to the base, while the card below depicts a T-33 jet trainer that was used to train air force pilots at the base.

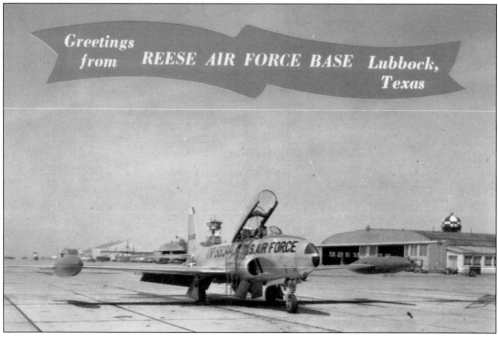

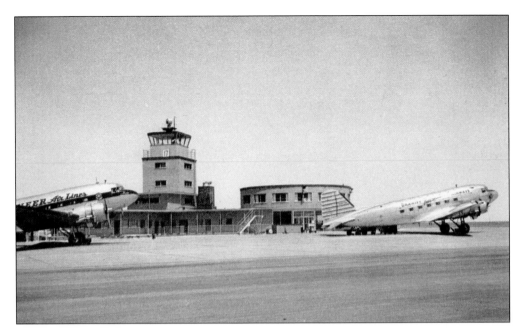

LUBBOCK AIRPORT (ABOVE, DEXTONE, 1955; BELOW, CURTEICH—LUBBOCK NEWS AGENCY, 1958). The original Lubbock airport was opened in November 1937 as South Plains Airport. During World War II, the airport was used as South Plains Army Airfield for the training of glider pilots. Commercial airline service began on July 1, 1945, with a flight to Dallas, operated by Braniff Airways. Pioneer Airlines, Continental Airlines, and Trans-Texas Airlines soon began serving Lubbock, and a new terminal was built in 1950. In 2004, the airport was named Preston Smith International Airport in honor of the former governor of Texas. The current terminal was built in 1976, and the old terminal became the Silent Wings Museum in 2004. Both postcards shown here depict the old terminal and tower.

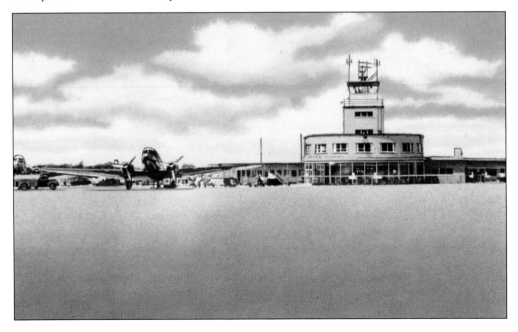

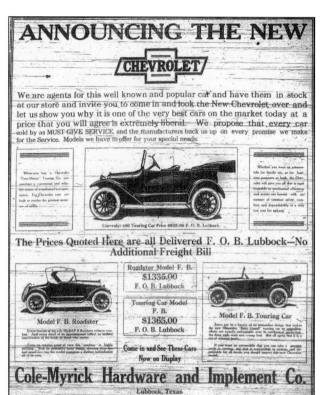

Cole-Myrick Hardware and Implement Co.
Lubbock, Texas

LUBBOCK AVALANCHE-JOURNAL, OCTOBER 27, 1919. Cole-Myrick Hardware and Implement Company in Lubbock was advertising the 1919 Chevy roadster for $1,335 and the Chevy touring car for $1,365. In today's prices, gasoline in 1919 was about $3 per gallon. The average annual income in 1919 was $3,724, so driving was an expensive venture. Not only that, but there was still very little paving; most roads were still dirt or, usually, mud. (Courtesy of the *Lubbock Avalanche-Journal*.)

LUBBOCK EVENING JOURNAL, NOVEMBER 10, 1954. This 1954 advertisement from the *Lubbock Evening Journal* is announcing the new Cadillac for 1955 from Alderson Cadillac. Jack Alderson was general manager of a local Chevrolet dealership in 1949 when he took the opportunity to run the Cadillac franchise in Lubbock at 814 Avenue H. In 1956, Alderson moved to a new location at 1210 Nineteenth Street, where the dealership remains to this day—still owned by family. (Courtesy of the *Lubbock Avalanche-Journal*.)

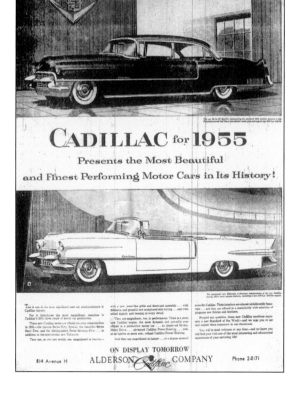

Six

CHURCHES, SCHOOLS, AND HOSPITALS

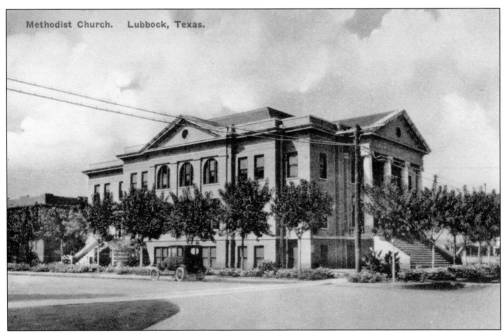

Methodist Church. Lubbock, Texas.

METHODIST CHURCH, LUBBOCK, TEXAS, 1925 (HAND COLORED, ALBERTYPE—MOLINE'S STUDIO, LUBBOCK). When the old wooden church burned in 1917, First Methodist Church of Lubbock, seen on this card, was completed in 1918. Constructed of gray brick, it contained a full basement and a sanctuary with a balcony extending around both sides and the rear. It was located on the corner of Broadway Avenue and Thirteenth Street.

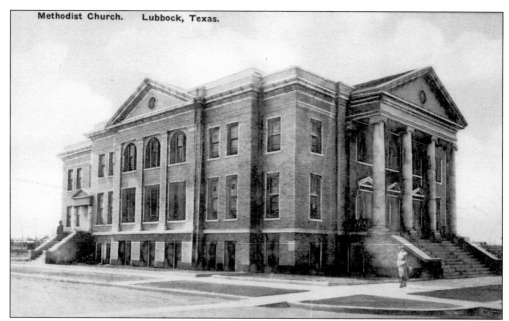

METHODIST CHURCH, LUBBOCK, TEXAS, 1920 (ALBERTYPE—MOLINE'S STUDIO, LUBBOCK). This photograph postcard from about 1920 shows the second structure of First Methodist Church. This building was completed in 1918 and was used until the present-day church was dedicated in 1955. Today an original portion of one of the columns from this 1918 structure remains on the grounds of First United Methodist Church with a historical marker.

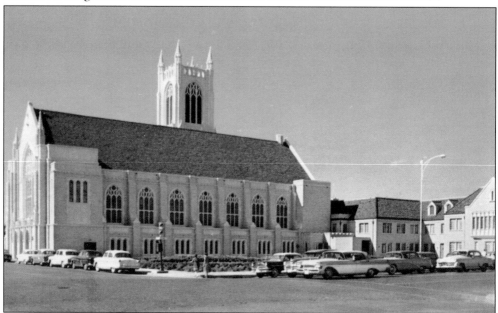

FIRST METHODIST CHURCH, LUBBOCK, TEXAS, 1955 (CURTEICH COLOR—LUBBOCK NEWS AGENCY). The new First Methodist Church broke ground in 1952 and was dedicated in 1955. With its massive stained-glass windows, the church is known as the "Cathedral of the West." Above the altar is the famous Rose Window, measuring over 26 feet in diameter, with a design based on the Creation. The church held its first Sunday worship in the building on March 6, 1955.

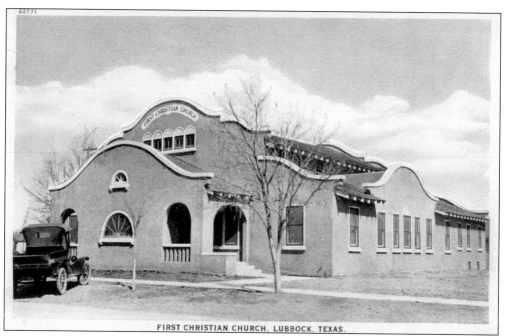

FIRST CHRISTIAN CHURCH, LUBBOCK, TEXAS.

THE FIRST CHRISTIAN CHURCH, LUBBOCK, TEXAS, 1928 (SKY-TINT). The First Christian Church of Lubbock was a stucco-over-frame structure in Spanish, semi-tabernacle style. It was located on the site of the old building on Avenue J at Sixteenth Street. The building was dedicated on Sunday, September 30, 1923. Rev. J. B. Holmes of Fort Worth, Texas, the secretary of the Texas Christian Missionary Society, was in charge of the dedication services.

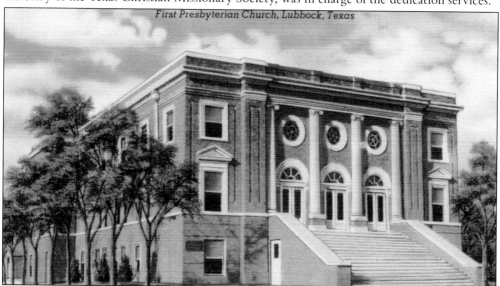

First Presbyterian Church, Lubbock, Texas

FIRST PRESBYTERIAN CHURCH, LUBBOCK, TEXAS, 1935 (COLOURPICTURE—BAXTER LANE). The Presbyterian church has been a part of the growth and development of Lubbock since before the city was incorporated in 1909. This 1935 postcard shows the First Presbyterian Church in downtown Lubbock. Later, First Presbyterian was located at Fourteenth Street and Avenue O. In May 2006, the church sold the downtown property to the YWCA after it opened its new church at 130th Street and Memphis Avenue in South Lubbock.

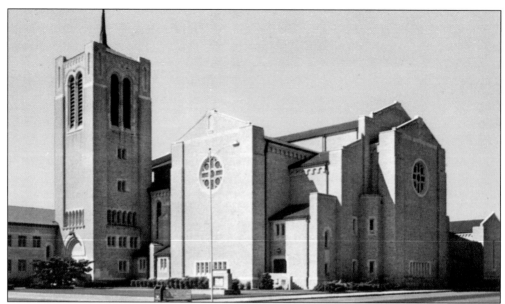

First Baptist Church, Lubbock, Texas, 1955 (Curteich Color—Lubbock News Agency). The First Baptist Church of Lubbock began in 1891, when missionary Rev. T. H. Stamps gathered local settlers to organize the congregation. They met in the old jail at Main Street and Avenue G and later in the courtroom of the new county courthouse in 1892. After several downtown buildings, the church shown in this card, located at Broadway and Avenue V, was dedicated in 1951.

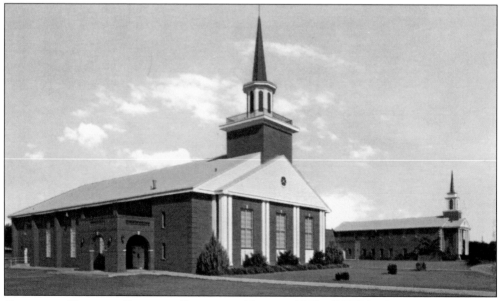

Oakwood Baptist Church, Lubbock, Texas, 1965 (MWM Company, Aurora, Missouri). Oakwood Baptist Church is located at Sixty-sixth Street and Avenue U in South Central Lubbock. Oakwood Baptist has long been known for its church and mission for the deaf, which offer interpreted and deaf-led services to the hearing impaired. The church has greatly expanded since this image was taken and now comprises a new sanctuary and family fellowship and recreation center.

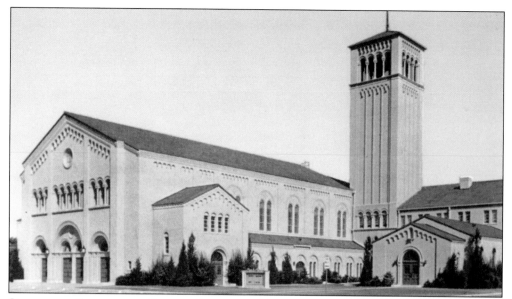

BROADWAY CHURCH OF CHRIST, LUBBOCK, TEXAS, 1955 (CURTEICH COLOR—LUBBOCK NEWS AGENCY). Members of the Church of Christ gathered in many different places before building a meeting place in Lubbock in 1906. A small frame building was built near the Santa Fe tracks, but the church later moved to Tenth Street and Avenue L. In the 1920s, the church began its new building at Broadway and Avenue N. This is its present-day location, shown in 1955.

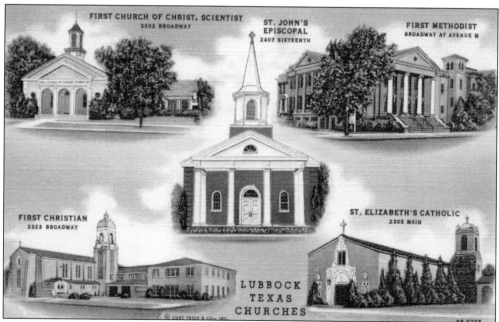

CHURCHES OF LUBBOCK, TEXAS, 1955 (CURTEICH COLOR—LUBBOCK NEWS AGENCY). This postcard shows five of the large main Lubbock churches in the 1950s. The large churches on Broadway are First Church of Christian Science, First Methodist, and First Christian. Also shown are St. Elizabeth's Catholic Church on Main Street and St. John's Episcopal Church on Sixteenth Street.

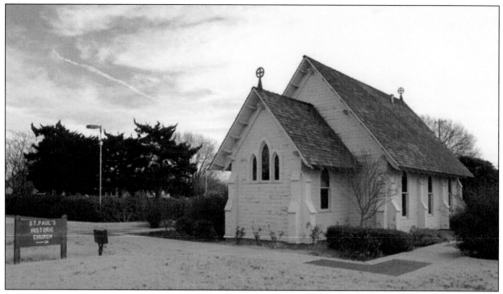

ST. PAUL ON THE PLAINS EPISCOPAL CHURCH. St. Paul on the Plains Episcopal Church is the oldest building still standing in Lubbock. The church was built in 1910 at Avenue Q and Fifteenth Street. In 1927, the building was moved to 1609 Avenue Q. In 1997, it was moved once more to Hodges Park at Forty-fourth Street and University Avenue and restored through gifts to the Lubbock Heritage Society. It is now used for weddings, family reunions, and other social gatherings. (Courtesy of the *Lubbock Avalanche-Journal*.)

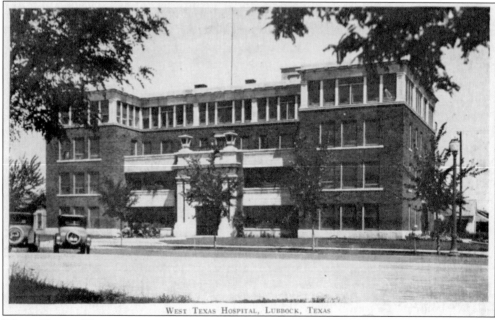

WEST TEXAS HOSPITAL, LUBBOCK, TEXAS

WEST TEXAS HOSPITAL, LUBBOCK, TEXAS, c. 1925 (HASKELL POSTCARD). West Texas Hospital opened in 1922 as the third hospital in Lubbock. The opening of Texas Technological College in 1925 and subsequent growth of the city population saw a number of doctors coming to Lubbock and establishing their practices with the new hospital. Dr. C. J. Wagner, Dr. W. L. Baugh, and Dr. R. J. Hall formed the West Texas Hospital Association.

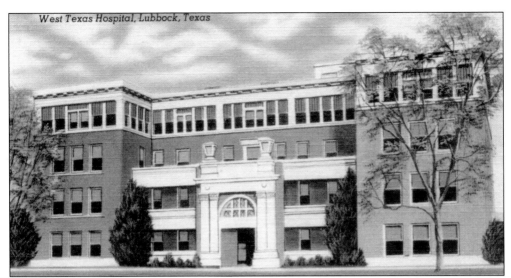

West Texas Hospital, Lubbock, Texas

WEST TEXAS HOSPITAL, LUBBOCK, TEXAS, C. 1941 (MARK HALSEY DRUG—REEVES PHOTOGRAPH). When the new West Texas Hospital opened in 1922, it had 40 beds and modern equipment. Owned by the West Texas Hospital Association, it was the first hospital in Lubbock that was owned by someone other than physicians. Demands on the facility increased rapidly, and additional space was created by adding an additional story to the three-story building and increasing the number of beds to 60 total.

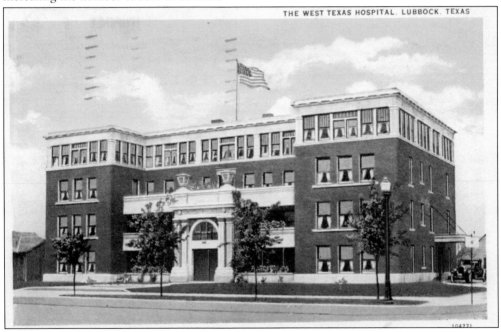

THE WEST TEXAS HOSPITAL, LUBBOCK, TEXAS

WEST TEXAS HOSPITAL, LUBBOCK, TEXAS, POSTMARKED 1935 (C. T. AMERICAN ART). The facilities of the West Texas Hospital were expanded again in 1940, 1950, and 1953, bringing the number of beds to 140 total. The hospital was closed staffed, meaning all the nurses and physcians worked in only one area of specialization, and Dr. W. L. Baugh stated that all the doctors on the West Texas Hospital staff were handpicked and he did not want any strangers on his staff.

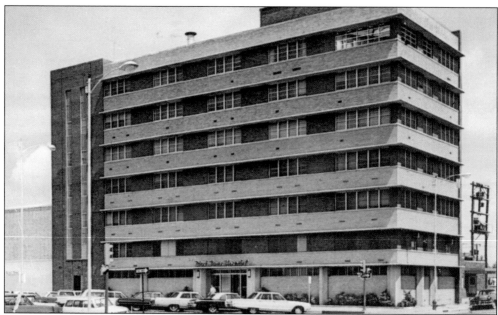

West Texas Hospital, Lubbock, Texas, Postmarked 1966 (Curteich Color). This is a more modern version of West Texas Hospital at 1302 Main Street in the 1960s. This building was later sold to South Plains College for use as classrooms. The college later moved its Lubbock campus locations to the Byron Martin Advanced Technology Center and to the Reese Technology Center. Today the building is used for office space as the Lubbock Main Center.

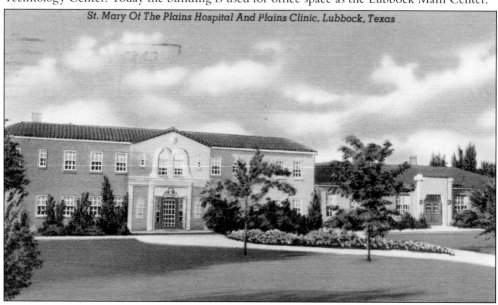

St. Mary of the Plains Hospital and Plains Clinic, Lubbock, Texas, Postmarked 1958 (Colourpicture—Baxter Lane). In January 1937, the Plains Clinic opened as a partnership between three doctors. They soon realized that the operation of the clinic was more than they could handle and sought to sell the hospital to other interests. The Sisters of St. Joseph purchased the facility on July 15, 1939, and the institution's name was changed from the Plains Clinic to St. Mary of the Plains Hospital, which is seen on this postcard.

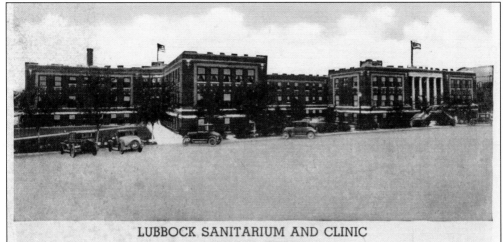

LUBBOCK SANITARIUM AND CLINIC
LUBBOCK, TEXAS

One hundred twenty-five beds, fireproof construction, every modern convenience. Completely equipped to care for medical, surgical, dental and obstetrical cases. Modernly equipped nursery. Complete x-ray and pathological laboratories and radium. A chartered training school for nurses is conducted in connection with the sanitarium.

LUBBOCK SANITARIUM AND CLINIC, C. 1935 (C. T. AMERICAN ART). The city's first hospital, the Lubbock Sanitarium, was located at what is now Main Street and Avenue O, on a pair of lots then owned by Dr. M. C. Overton, but it closed in April 1912. Dr. Charles F. Clayton and Dr. Overton eventually reopened the original sanitarium, but it soon failed as well. Overton later opened his own hospital in the 1000 block of Texas Avenue, calling it Overton Sanitarium.

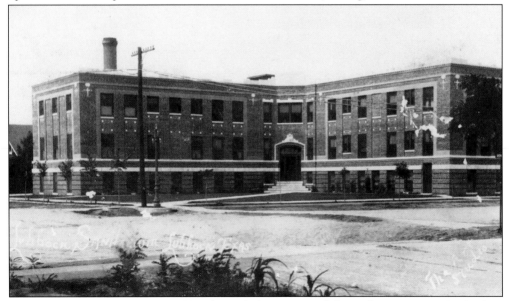

WEST TEXAS SANITARIUM, C. 1920. This real photo postcard shows the West Texas Sanitarium shortly after it opened 1918. In 1917, a three-story brick building was constructed at Tenth Street and Texas Avenue called the West Texas Sanitarium and leased to Dr. M. C. Overton and Dr. C. J. Wagner. Later that year, Dr. J. T. Hutchinson and Dr. A. R. Ponton began building a new Lubbock Sanitarium at Broadway and Avenue L. This would later become Lubbock General Hospital and eventually Methodist Hospital.

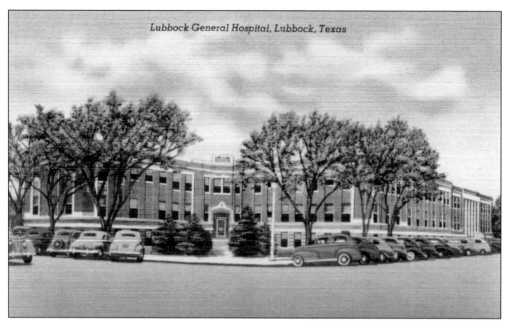

Lubbock General Hospital, Lubbock, Texas

LUBBOCK GENERAL HOSPITAL, LUBBOCK, TEXAS, C. 1942 (COLOURPICTURE—MARK HALSEY DRUG). In 1942, Lubbock Sanitarium's doctors incorporated the facility and changed the name to the Lubbock General Hospital. The name was changed again in 1943 to the Lubbock Memorial Hospital to honor those Lubbock men and women who gave their lives in World War II. This postcard from about 1940 depicts the hospital around the time of the name change.

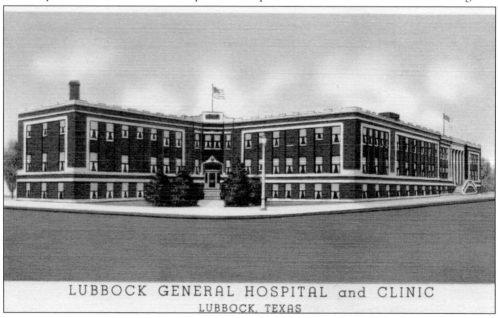

LUBBOCK GENERAL HOSPITAL and CLINIC
LUBBOCK, TEXAS

LUBBOCK GENERAL HOSPITAL AND CLINIC, LUBBOCK, TEXAS, C. 1942 (CURTEICH). The back of this card states, "One hundred beds, fireproof construction, every modern convenience. Completely equipped to care for medical, surgical, and obstetrical cases. Modernly equipped nursery. Complete x-ray and pathological laboratories and radium. A chartered school of nursing is conducted in connection with the hospital."

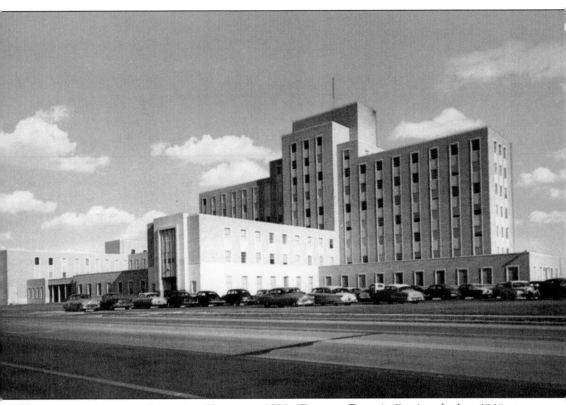

METHODIST HOSPITAL, LUBBOCK, TEXAS, C. 1958 (DEXTER PRESS). During the late 1940s, the owners of the Lubbock Memorial Hospital began considering plans for a much larger facility. The new facility, located on the west end of town at 3615 Nineteenth Street, was opened to the public on August 3, 1953. In the following year, Lubbock Memorial Hospital was changed to Methodist Hospital when the Northwest Texas Conference of the United Methodist Church voted to assume ownership of the Lubbock Memorial Hospital. This postcard from the late 1950s shows the new Methodist Hospital on Nineteenth Street during its early years of operation. The Covenant Health System was founded in 1998 through the merger of St. Mary of the Plains Hospital and Lubbock Methodist Hospital System. Today the Nineteenth Street facility is known as Covenant Medical Center, and the old St. Mary of the Plains Hospital is known as Covenant Medical Center–Lakeside. Covenant Health System is the largest health care institution in the West Texas and Eastern New Mexico region. (Convent Health System.)

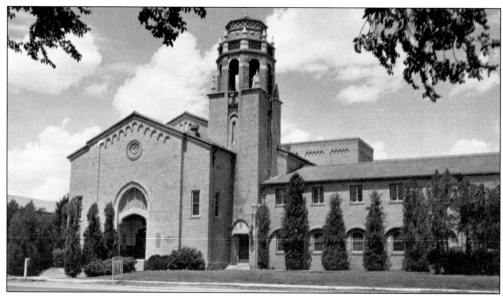

LUBBOCK SENIOR HIGH SCHOOL (ABOVE, DEXTONE—HERALD PHOTOGRAPH, 1958; BELOW, CURTEICH, 1939). In 1891, Minnie Tubbs opened the first school in Lubbock. Construction of the high school, seen on these two cards, was begun in 1930. The school board appropriated $650,000 for the new building on Nineteenth Street, which was a controversial location, because some parents felt that the new high school was too far from town, which meant their children would have long horse rides to school. The contractor, D. N. Leaverton, depleted the $650,000 before the building was completed. However, because he refused to compromise on the workmanship or materials in the new school, he sold his family's oil fields in East Texas to have the money to complete the building. He went broke and never built another building after completing Lubbock High School in 1931.

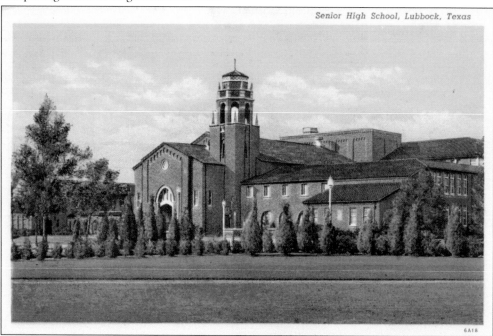

Senior High School, Lubbock, Texas

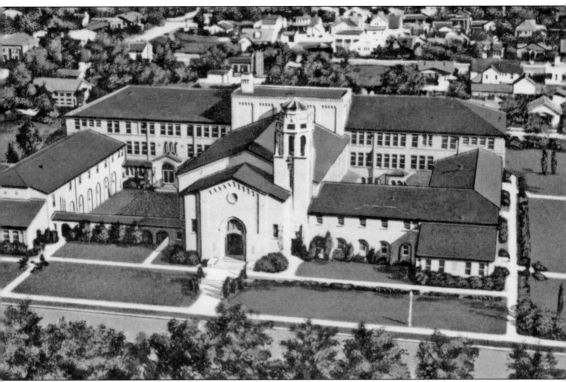

SENIOR HIGH SCHOOL, LUBBOCK, TEXAS, POSTMARKED 1952 (CURTEICH—LUBBOCK NEWS AGENCY). This 1952 postcard is an aerial view of Lubbock High School's campus on Nineteenth Street. The original building consisted of two-and three-story classroom wings, offices, a gymnasium, and an auditorium, all constructed around two open courtyards. As the city expanded and the population grew, Lubbock High School's facilities were expanded several times to meet the needs of the Lubbock Independent School District (LISD). This image shows the proximity of the school to Nineteenth Street and to the surrounding neighborhood. The architecture of the building is North Italian Romanesque and features decorative brickwork, terra-cotta ornamentation, and a bell tower. The building is listed on the National Register of Historic Places and is the alma mater of Lubbock's most famous son, Charles Hardin Holley, better known as Buddy Holly.

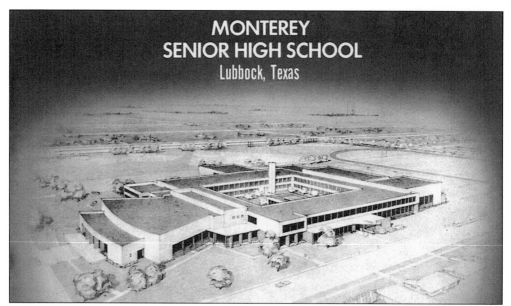

MONTEREY
SENIOR HIGH SCHOOL
Lubbock, Texas

MONTEREY SENIOR HIGH SCHOOL, LUBBOCK, TEXAS, 1955. As Lubbock continued to grow, the need for a new high schools became apparent. In September 1955, Monterey High School opened its doors on Fiftieth Street, and a new crosstown rivalry was born between the Plainsmen and the Westerners. Monterey and Lubbock High Schools play for the bragging rights of the "Silver Spurs" every fall during football season. Shown here is the cover from the dedication ceremony program for Monterey High School in 1955.

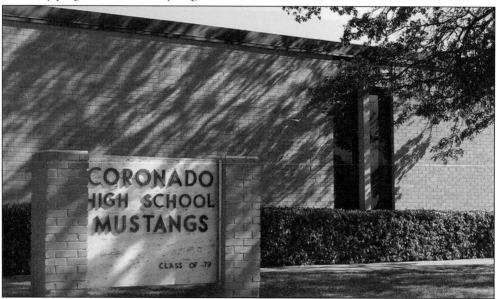

CORONADO SENIOR HIGH SCHOOL, LUBBOCK, TEXAS (LISD). In 1965, the Lubbock High student body was divided once again, as Coronado High School, named for the Spanish explorer Francisco Vasquez de Coronado, opened at 3307 Vicksburg Avenue, creating more crosstown rivalries. Coronado features a rigorous college preparatory academic program, 20 advanced placement courses, and a dual credit enrollment program for high school students to receive college credit in conjunction with South Plains College.

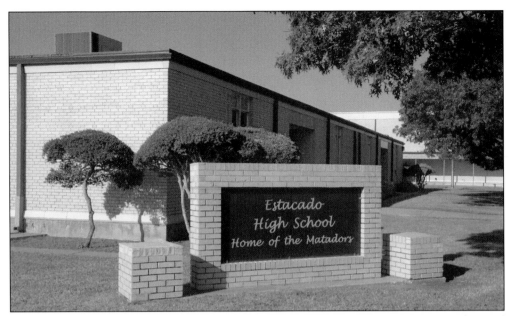

ESTACADO HIGH SCHOOL (LISD). Constructed in 1967, Estacado High School is a professional career magnet school offering medical, law and justice, science, and military specializations. The campus includes a modern brick building and on-site baseball, football, and gymnasium facilities. Technology is integrated into the learning process at Estacado. Students have access to Internet-ready computers in every classroom, and the school has 5 computer labs with 25 computers each.

DUNBAR HIGH SCHOOL (LISD). According to LISD records, Dunbar High School was originally built in 1922 and upgraded in 1935. It was named for Paul Lawrence Dunbar, an eminent and prolific African American poet and writer. In August 1993, through an LISD reorganization plan that started in 1970, Dunbar opened as a magnet junior high school science academy and no longer served the Lubbock community as a senior high school.

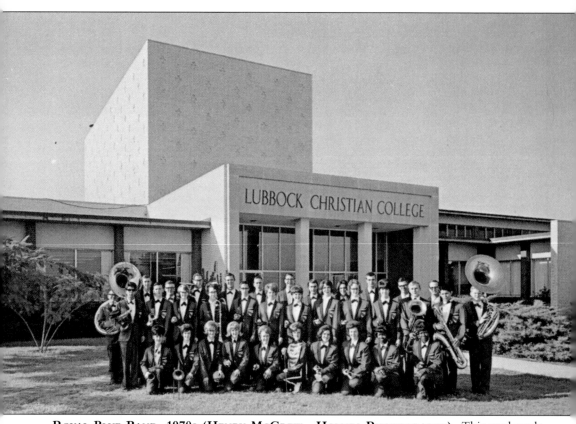

Royal Blue Band, 1970s (Henry McGrew—Holmes Photography). This card reads, "Lubbock Christian College is fully accredited by the Southern Association of Colleges. Located at 5601 West Nineteenth Street, Lubbock, Texas, its course of study includes the liberal arts, plus a technical-vocational program. It emphasizes high academic achievement and offers a wide variety of student activities." The ground-breaking for the new college took place on May 4, 1957. When LCC opened its doors in 1957, the mascot was a pioneer. The school began searching for a new mascot in 1964, because LCC and Wayland Baptist shared the same mascot, and the chaparral emerged as the new mascot. In 1970, the decision was made to make the move from a two-year junior college to a four-year institution of higher learning. In the spring of 1987, the Lubbock Christian College Board of Trustees officially voted to begin the transition to become a university. Shown here is the Royal Blue Band of Lubbock Christian College in the 1970s.

Seven

PARKS AND RECREATION

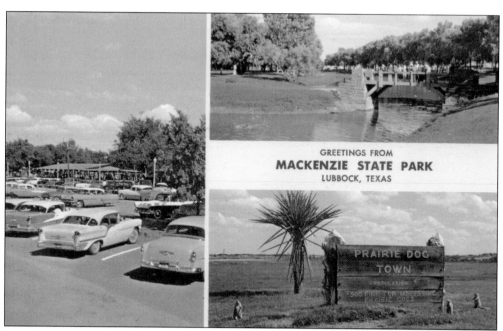

GREETINGS FROM MACKENZIE STATE PARK, LUBBOCK, TEXAS, C. 1955 (CURTEICH—LUBBOCK NEWS AGENCY). Mackenzie Park is located at 302 Interstate 27 in Lubbock. It is named for Col. Ranald Slidell Mackenzie of the 4th United States Cavalry, who cleared the Native American threat from the region. It is a 500-acre park that has picnic and camping facilities, fishing, swimming pool, golf course, disk golf course, hiking trails, museums, Prairie Dog Town, and an amusement park.

MACKENZIE STATE PARK (ABOVE, CURTEICH—LUBBOCK NEWS AGENCY, 1955; BELOW, DEXTONE—HERALD PHOTOGRAPH, 1955). Mackenzie Park, named for Col. R. S. Mackenzie, was established in 1935 as a cooperative effort of the state, city, and county. Lubbock County began the events that would lead to the development of the park, purchasing 80 acres of land just east of the city in 1919. Seven years later, Mollie Abernathy donated 138 acres in Northwest Lubbock for the establishment of a park. That led to the creation of City Park No. 1, the forerunner to Mackenzie. In 1935, Abernathy sold the city an additional 332 acres of real estate in Yellow House Canyon and insisted the land be used for a park, and language in the contract stipulated the acreage would be returned if used for anything else, according to the City of Lubbock. The two postcards shown here depict scenes in Mackenzie Park during the 1950s.

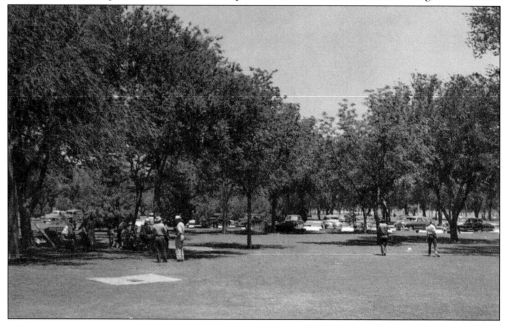

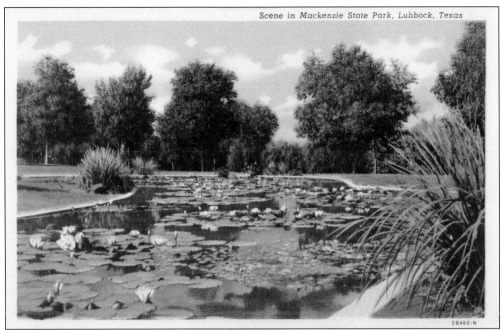

Scene in Mackenzie State Park, Lubbock, Texas

28460-N

MACKENZIE STATE PARK (BOTH, CURTEICH—LUBBOCK NEWS AGENCY, 1945). By the summer of 1935, the 200-man Civilian Conservation Corps (CCC) Company 3820 had planted thousands of trees and also built bridges and recreational facilities in Mackenzie Park. Once the CCC completed its work and the park was opened, Lubbock asked the state to deed the land back to the city so that it could be maintained locally. This unusual arrangement—a state park overseen by a local municipality—was in place until 1993, when the city took possession of Mackenzie in a move that passed ownership of the Lubbock Lake Landmark site to the state. Long before the park was established, the area was home to the Tumble N, a private swimming pool built in 1921, and the 1923 public golf course, which would eventually become Meadowbrook Golf Course, according to the City of Lubbock.

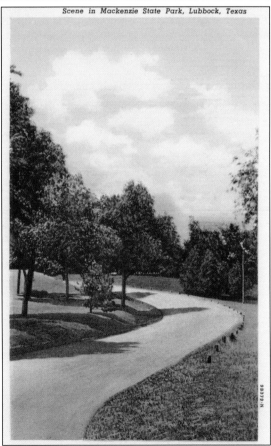

Scene in Mackenzie State Park, Lubbock, Texas

9B372-N

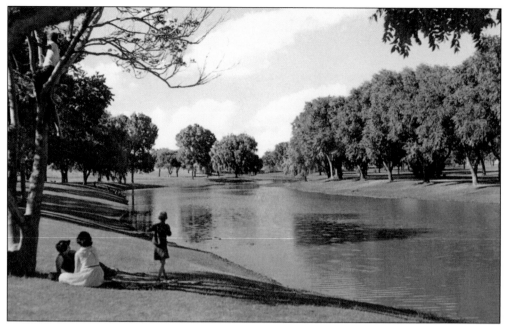

MACKENZIE STATE PARK, LUBBOCK, TEXAS, 1950s (BOTH, CURTEICH—LUBBOCK NEWS AGENCY). The 1940s saw the addition of the Mackenzie Park Playground, which later became Joyland Amusement Park. In 2006, the Wells Fargo Amphitheater was opened, providing another entertainment option. The park, in addition to hiking trails and picnic areas, is also home to a disk golf course and equestrian trails. Today Mackenzie is Lubbock's largest recreational area and hosts the city's annual July Fourth fireworks display and a number of other events throughout the year. Mackenzie Park is located on East Broadway at Avenue A. Across Broadway from the park is the American Wind Power Museum and the American Museum of Agriculture. These two postcards depict some of the water features of the park.

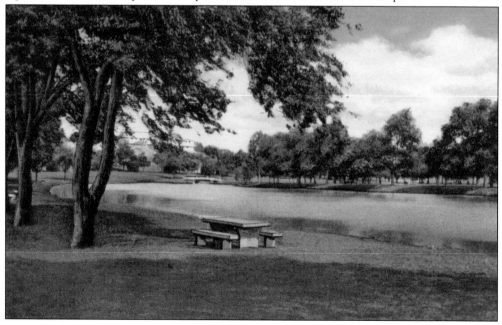

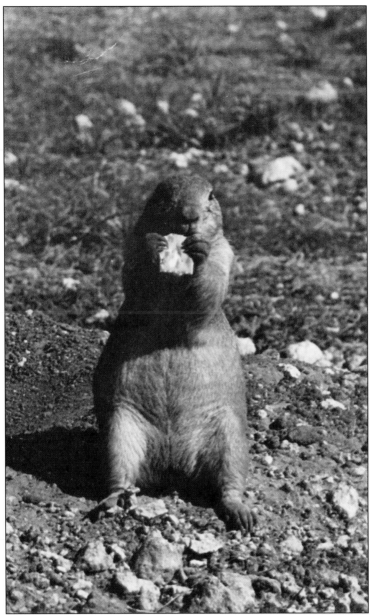

PRAIRIE DOG TOWN, LUBBOCK, TEXAS, C. 1955 (DEXTONE—HERALD PHOTOGRAPH). Kennedy N. Clapp and his wife established Prairie Dog Town in Mackenzie Park in the early 1930s. It was started with four dogs and two burrows and was the first protected prairie dog colony of its kind. The colony was moved to its current location in 1935, when Mackenzie Park became a state park. For his contribution to Lubbock and prairie dogs, Kennedy Clapp was named mayor of Prairie Dog Town in perpetuity. Within its first five years at its new location, Prairie Dog Town became world famous and a favorite tourist attraction with its own goodwill ambassador, Prairie Dog Pete. A Lubbock Convention and Visitor's Bureau tourism study showed Prairie Dog Town as the fifth most visited attraction in Lubbock by visitors from outside the city. Prairie Dog Town is open to the public from dawn until dusk and is also home to burrowing owls.

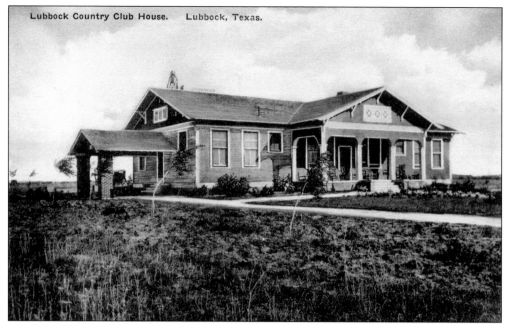

Lubbock Country Club House. Lubbock, Texas.

LUBBOCK COUNTRY CLUBHOUSE, LUBBOCK, TEXAS, *c.* 1925 (ALBERTYPE—MOLINE'S STUDIO, LUBBOCK, TEXAS). The Lubbock Country Club, established in 1921, lies in the historic Yellow House Canyon. It is a member-owned private club. Its members are primarily professional people such as physicians, professors, business owners, farmers, salespeople, and their families. This real photo postcard shows the original clubhouse in the 1920s.

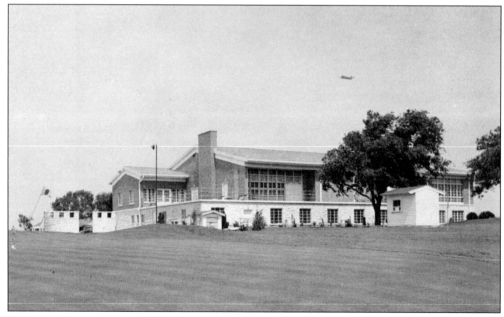

LUBBOCK COUNTRY CLUB, LUBBOCK, TEXAS, *c.* 1950 (DEXTONE—HERALD PHOTOGRAPH). This photo postcard is of the modern clubhouse of the Lubbock Country Club at 3400 Mesa Road. The modern club is known for its 18-hole golf course, pool, tennis, and banquet facilities. The Lubbock Country Club is the oldest private club in Lubbock.

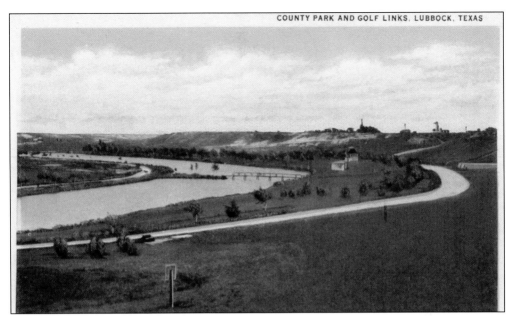

COUNTY PARK AND GOLF LINKS, LUBBOCK, TEXAS, 1931 (C. T. AMERICAN—CHAPMAN NEWS AGENCY, LUBBOCK, TEXAS). Situated in Yellow House Canyon, Meadowbrook features groves of elm trees and flowing creeks. Originally an 18-hole golf course when it was built by W. G. McMillan Sr. in 1931, it was later expanded to 27 holes. Today's Canyon Course was called the Meadowbrook Course in 1931. The 9-hole course was once known as Old Squirrel Hollow but is now called the Creek Course and has since been expanded to a full 18-hole course.

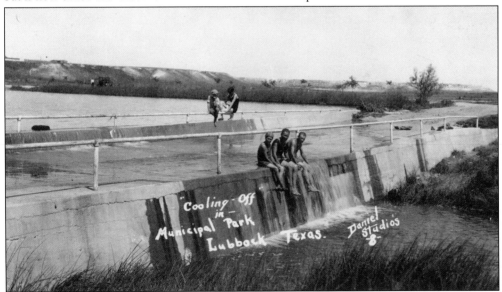

COOLING OFF IN MUNICIPAL PARK, LUBBOCK, TEXAS, C. 1925 (DANIEL STUDIOS, LUBBOCK, TEXAS). Yellow House Canyon was the site of the last fight in Lubbock County between buffalo hunters and Native Americans in 1877. Spanish explorers knew of this area as early as the 17th century. This real photo postcards shows young boys cooling off in what was then Municipal Park in the Yellow House Canyon in the 1920s. This area later became a part of Mackenzie State Park.

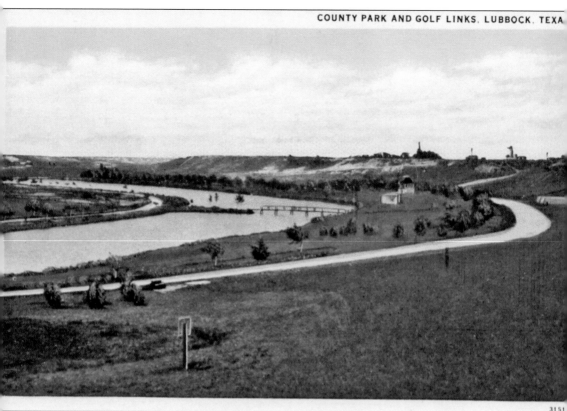

3151

LOWER LAKE, BUFFALO SPRINGS PARK, NEAR LUBBOCK, TEXAS, POSTMARKED 1956 (CURTEICH—LUBBOCK NEWS AGENCY). Buffalo Springs was used by buffalo hunters in the 1870s. By 1878, ranchers were moving into the area, and picnics and outings were popular. During the 1920s, the popularity of the area grew, and the Buffalo Lakes Association was formed to manage the property and sell memberships. Early members of the association built cabins around the lake. In 1957, the Lubbock County Water Control and Improvement District No. 1 bought 1,612 acres around Buffalo Lake to provide a community recreation center. The lake is governed by a five-member board elected by county voters, and residents lease land from the county and pay for their own improvements. The Buffalo Springs Lake area provides a variety of recreational activities for residents and for visitors through waterskiing, fishing, boating, horseback riding, hiking, and camping. A variety of special events are also held at the lake, including boat races, marathons, and country music programs. It is estimated that one million people visit the recreational area of Buffalo Springs Lake each year.

Eight

HOTELS, MOTELS, AND RESTAURANTS

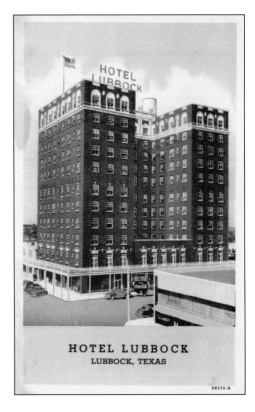

HOTEL LUBBOCK, c. 1941 (CURTEICH—LUBBOCK NEWS AGENCY). One of the most distinguishable landmarks in downtown Lubbock is the old Hotel Lubbock, at Broadway and Avenue K. The building stood six stories when it first opened in 1929. The remaining five stories were added in the early 1930s. It served as Lubbock's finest hotel and was used to host civic events and major celebrations.

HOTEL LUBBOCK
LUBBOCK, TEXAS

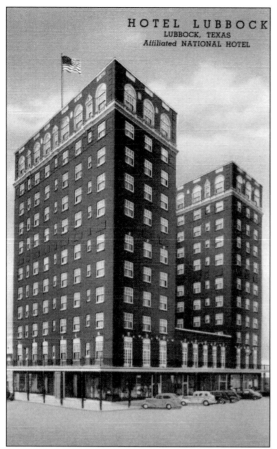

HOTEL LUBBOCK
LUBBOCK, TEXAS
Affiliated NATIONAL HOTEL

HOTEL LUBBOCK (LEFT, CURTEICH, 1935; BELOW, C. T. AMERICAN, 1929). The card at left states, "Completely renewed throughout, 300 rooms conveniently located near theatrical and shopping district. Moderate rates prevail throughout. The Coffee Shop is Lubbock's most inviting eating room." On the third floor of the hotel was a stately ballroom that was the site of many important events and special occasions in Lubbock. The name of the hotel changed several times over the years, and the building eventually became a retirement home in the late 1990s. In 2005, the hotel was purchased by McDougal Companies to be restored and renovated into luxury condos in downtown Lubbock. Construction crews are building both a stairwell and elevator shaft and are using bricks closely matching the originals, according to McDougal Companies. On the third floor, work crews are restoring the original ballroom, which will contain both a banquet area and a service facility. In the lobby area, an original staircase leading to the ballroom will be given a makeover.

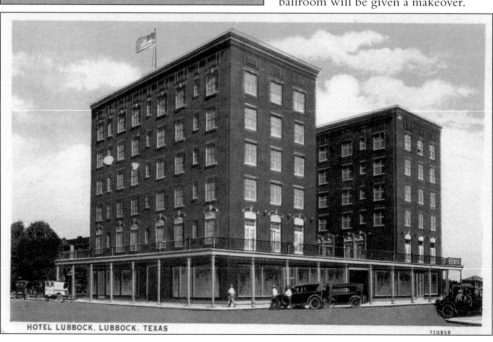

HOTEL LUBBOCK, LUBBOCK, TEXAS

HOWARD HOTEL, LUBBOCK, TEXAS, C. 1910. Lubbock's original hotel was the Nicolett Hotel, which had been moved from its original site in the old town of Lubbock to the new site when Lubbock and Monterey merged in 1890. The Nicolett was most likely the first hotel on the South Plains, but others soon emerged, such as the Howard Hotel, which can be seen in this real photo postcard from about 1910. Notice the horse-drawn wagons and the muddy streets.

CAMP-O-TEL, LUBBOCK, TEXAS, C. 1938 (MWM COLOR-LITHO). This card reads, "Lubbock's finest tourist hotel. Eighteen rooms and apartments, solid brick walls. Polished hardwood floors. New maple furniture, innerspring mattresses. Maid service. Bed clothes changed daily. Kitchenettes and refrigerators." This motel was located at 2311 Nineteenth Street, which is on the corner of Nineteenth Street and Avenue X.

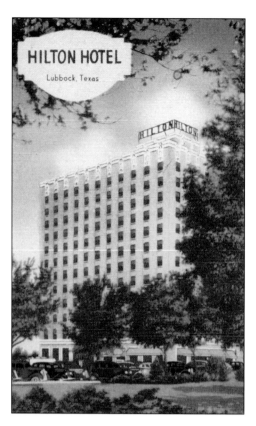

HILTON HOTEL, LUBBOCK, TEXAS (LEFT, MWM COLOR-LITHO, 1938; BELOW, CURTEICH, 1940). The Hilton Hotel in Lubbock was opened on January 8, 1929. As of February 1, 1929, Conrad Hilton reorganized the company into one corporation named Hilton Hotels, Inc., which included the Lubbock property as well as Dallas, Waco, Abilene, San Angelo, Plainview, and one other managed property in Wichita Falls. The Lubbock Hilton was the meeting place of many local clubs and groups, including the Lubbock Lions Club. The Hilton was a modern 12-story hotel with 200 rooms and was considered one of the finest hotels for 200 miles. The hotel was an example of Spanish-American architecture and ornamentation. The Hilton was sold in 1952 for $1,450,000.

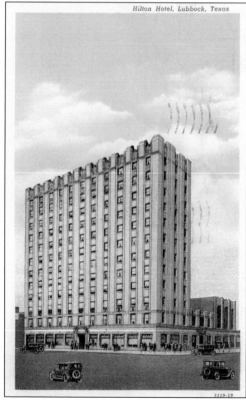

CAPROCK HOTEL, LUBBOCK, TEXAS, c. 1954 (CURTEICH). After the Hilton Hotel was sold in 1952, it became the Caprock Hotel. This card lists the Caprock Hotel as an Alsonett Hotel, with air-conditioning, television, and parking. The hotel was located on Main Street near the courthouse.

SUNSET LODGE MOTEL, LUBBOCK, TEXAS, c. 1945 (MOTEL CONTRACT SUPPLY CORPORATION). This card advertises the following: "Forty-two modern units—singles, doubles, connecting rooms, apartments—refrigerated air and vented heat—room telephones—tiled showers and tubs—children's playground—U.S. foam luxury bedding—television—cafe nearby." This motel was located at 2305 Clovis Highway, making it near the Texas Tech campus.

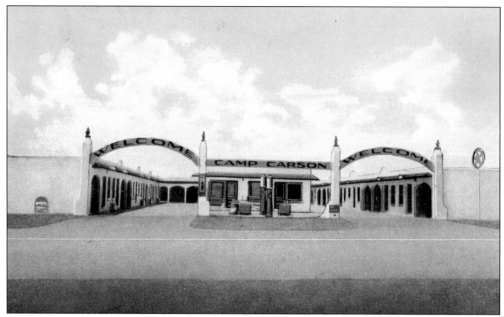

CAMP CARSON, LUBBOCK, TEXAS, C. 1945 (CURTEICH). This card proclaims that Camp Carson is "one of West Texas' finest tourist camps." This card also advertises Camp Carson as "three-fourths-mile from Square. Sixteen cottages built of brick and tile, plastered throughout; hardwood floors. Hot and cold water in every room. Base tubs and showers. Built in kitchen cabinets and gas ranges. Lunchroom and grocery in connection. Garage with every cottage."

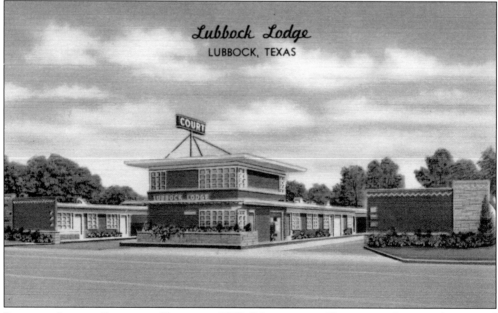

LUBBOCK LODGE, LUBBOCK, TEXAS, C. 1950 (NATIONWIDE POSTCARD COMPANY). Located at 4001 Nineteenth Street near the intersection of Highways 62 and 166, and now at the corner of Nineteenth Street and Brownfield Highway, the Lubbock Lodge boasted 24 units with air-conditioning, telephones, television, radio, and vented heat. This is near the present-day location of the Lubbock Inn.

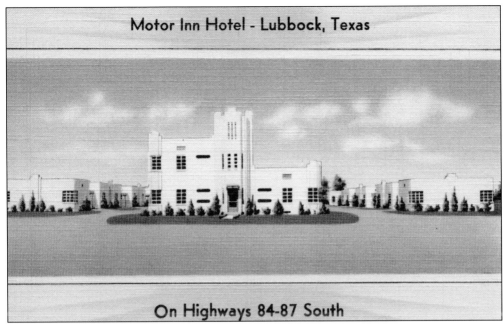

MOTOR INN HOTEL, LUBBOCK, TEXAS, C. 1938 (MWM COLOR-LITHO). "On Highways 84-87 South," the Motor Inn Hotel was part of a chain that had units in Lubbock, Wichita Falls, Fort Worth, Houston, Lawton, Oklahoma, and Baton Rouge, Louisiana. This motel was located at the intersection of present-day Slaton Road and Interstate 27. Today this address is the location of a Days Inn.

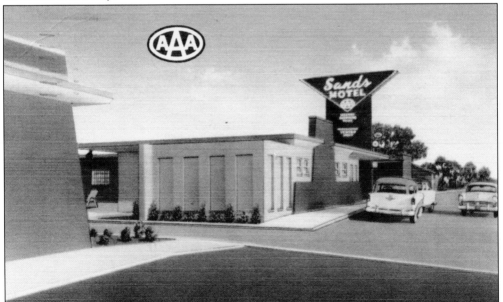

SANDS MOTEL, LUBBOCK, TEXAS, POSTMARKED 1958 (BONE-CROW). Located just north of Fourth Street on Avenue Q, the Sands Motel is advertised as "close to downtown Lubbock." When this postcard was printed, the population of Lubbock was 128,674. It states that the Sands has "wall-to-wall carpeting with tile combination baths, foam rubber luxury bedding, and Muzak in each room."

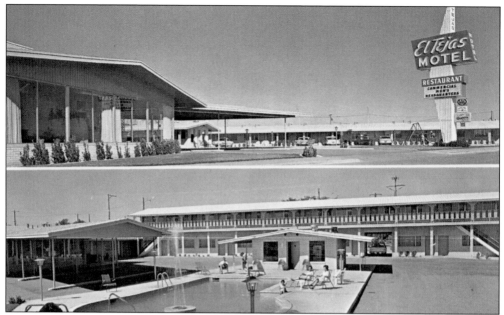

EL TEJAS MOTEL AND RESTAURANT, LUBBOCK, TEXAS, C. 1958 (WENDALL BAGWELL ENTERPRISES). El Tejas is a Best Western motel located on Highway 87 North at 1000 North Avenue Q Drive. Owned by Jim and Jo Etter, the motel is advertised as the "West Texas best" and "the finest motel accommodations for your comfort." AAA rated, El Tejas is still in business today in the same location.

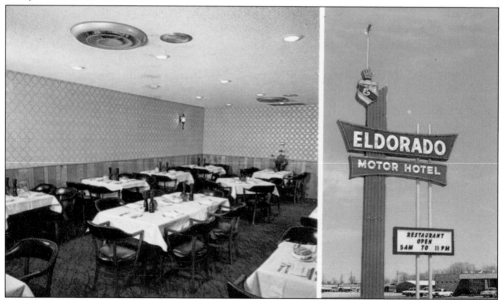

EL DORADO MOTOR HOTEL, LUBBOCK, TEXAS, POSTMARKED 1964 (AMERICAN INDUSTRIAL PICTURES). Located at 2120 Amarillo Highway, El Dorado was owned and managed by L. M. DeMarco and advertised "sixty individually heated and air conditioned rooms, executive suite, private dining room, spacious dining room, free airport limousine, free television, and direct dial phones." The card also claims "the largest heated swimming pool and only resort motel in West Texas."

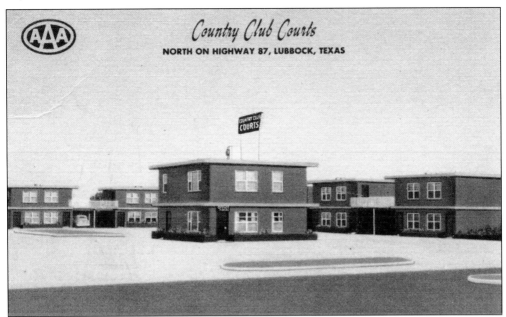

COUNTRY CLUB MOTEL (ABOVE, ADVANCE ADV COMPANY, HOUSTON, 1945; BELOW, DEXTER PRESS—HERALD PHOTOGRAPH, 1960). These two cards display the same motel in two different periods. The card above is the Country Club Courts in the mid-1940s. Located on North Highway 87, the card advertises "all modern deluxe furnishings" in 24 units. The card below is the same motel in the early 1960s, but now the name has changed to Country Club Motel and is now advertising "Beauty Rest mattresses, free television, and free coffee." It is located on the Amarillo Highway, about 1.5 miles north of the courthouse. By the 1960s, not only had the name and signs changed, but also awnings had been added to the front of all the buildings.

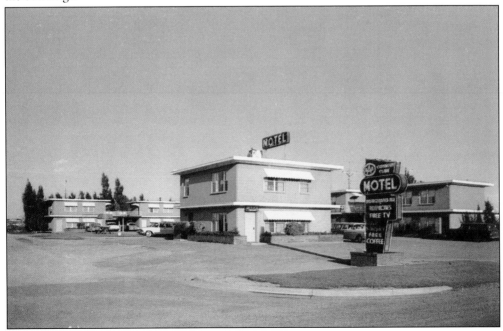

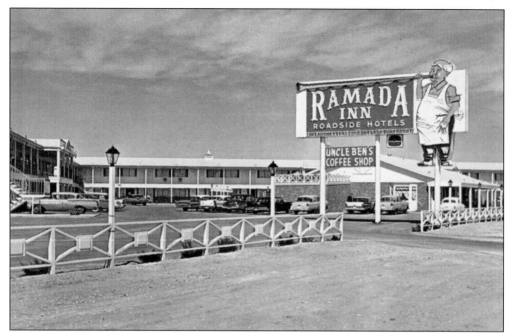

Ramada Inn, Lubbock, Texas, c. 1956 (Pentley Studios—Phoenix). The Ramada Inn, featuring Uncle Ben's 24-hour Coffee Shop, was located three minutes from the Lubbock Airport on U.S. Highway 87. The motel advertised 70 luxurious rooms, a swimming pool, and complete hotel service.

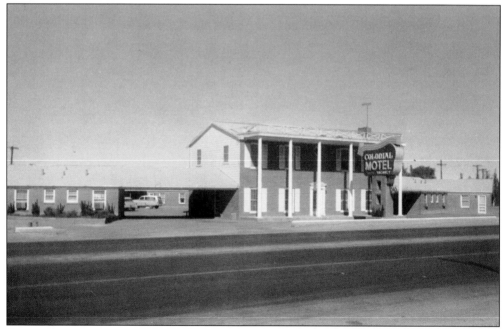

Colonial Motel, c. 1956 (Dexter Press—Reeves Camera Store). The Colonial Motel, at 416 Idalou Highway, was located at the junction of Highway 62, Highway 114, and East Broadway. This card advertises 30 spacious rooms with air-conditioning, television, and telephone in every room and a large playground for the children.

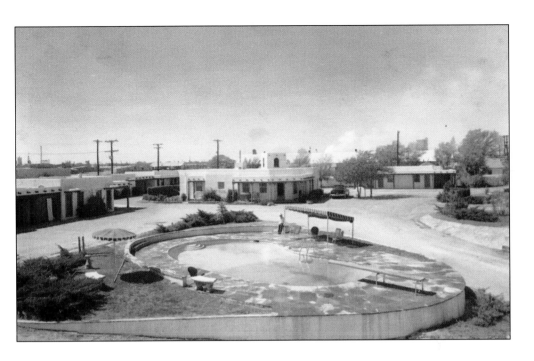

PARKVIEW LODGE (ABOVE, DEXTER PRESS, 1954; BELOW, DEXTONE—HERALD PHOTOGRAPH, 1956). These two postcards of the Parkview Lodge are from the mid-1950s. The Parkview Lodge was located at 500 East Broadway, overlooking Mackenzie State Park and the Panhandle South Plains Fair Fairgrounds. On Highways 62 and 82 Business Route, the motel was known for their restaurant and the close proximity to downtown and the park and fairgrounds. Today the lodge is gone, and the area is mainly warehouses and storage facilities.

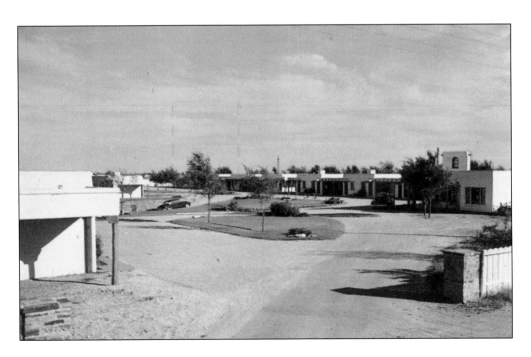

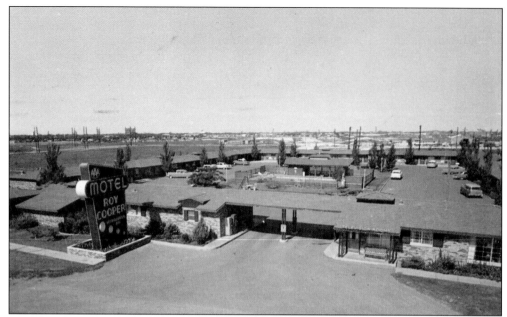

ROY COOPER MOTEL, LUBBOCK, TEXAS, POSTMARKED 1958 (DEXTER PRESS—REEVES PHOTOGRAPHY). The Roy Cooper Motel on North U.S. Highway 87 is touted on this card as "the West's best rest." The motel is advertised as "excellently furnished with individually controlled refrigerated air conditioning and vented gas heat. Large heated swimming pool, radios and television."

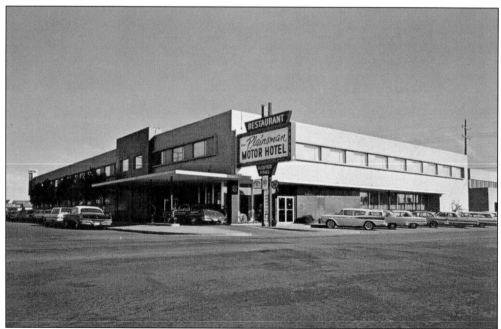

THE PLAINSMAN MOTEL, LUBBOCK, TEXAS, C. 1965 (MILLER-HOWARD OFFICE SUPPLY). The Plainsman Motel offered free transportation to and from the airport, as well as a coffee shop, dining room, heated pool, and off-street parking. Located at 2101 Avenue Q on Highway 84, the old motel building is now the Cornerstone Court Nursing Home.

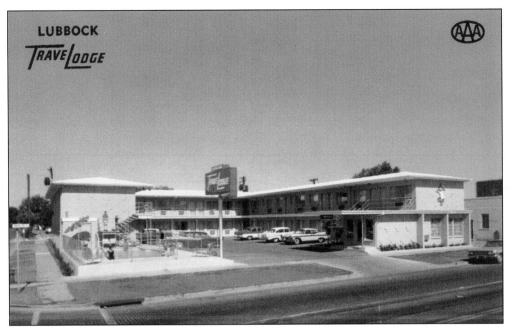

LUBBOCK TRAVELODGE. This 1958 postcard is of the Lubbock TraveLodge, located at 714 Avenue Q in downtown Lubbock. It is on Highway 84, near Highways 62 and 82, and claims to be the nearest motel to Texas Technological College. This is the present-day location of the Traveler's Inn on Avenue Q at Seventh Street, directly across from the Lubbock Memorial Civic Center.

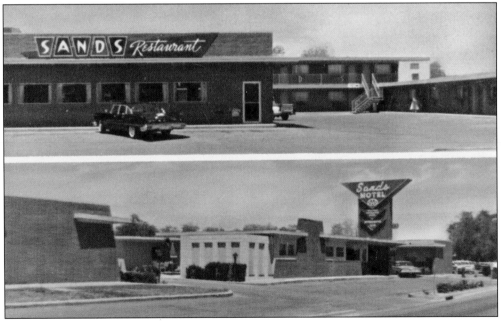

SANDS MOTEL, LUBBOCK, TEXAS, C. 1961 (JOHN B. HOWELL ADV. PROD. COMPANY). The Sands Motel in Lubbock was located at 310 Avenue Q and boasted 56 deluxe units with free television, Muzak, and a 24-hour switchboard. Its location made it close to both downtown and to the Texas Tech campus. This is now the location of the Inn of the South Plains.

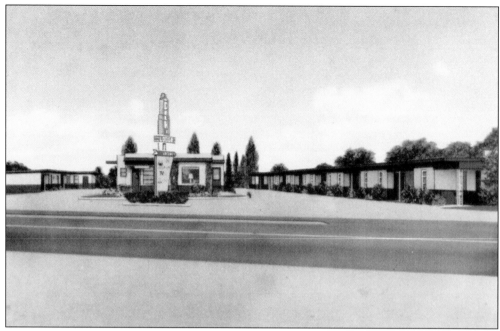

DELHI MOTEL, LUBBOCK, TEXAS, C. 1955 (STANDARD ADV. AND PRINTING). "A friendly place away from home," the Delhi Motel was on Idalou Road, which is East Highway 62 and 82 East. This card advertises television, radios, and room phones. The building is no longer standing.

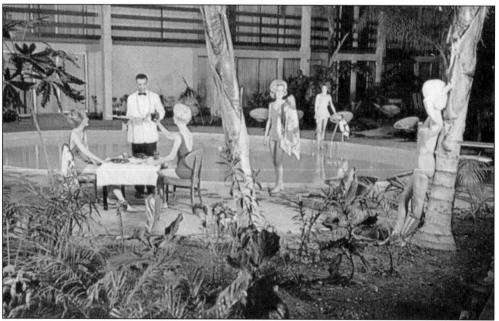

KOKO INN, LUBBOCK, TEXAS, C. 1960 (CURTEICH). Lubbock's KOKO Inn was known as one of the city's finest motels in the 1960s and 1970s. It is a full-service hotel and has an indoor heated swimming pool and a tropical atrium. The motel is known for its tropical atmosphere and fine dining. The KOKO is still in operation at the same location, which is right off of Interstate 27 near Fiftieth Street and Avenue Q.

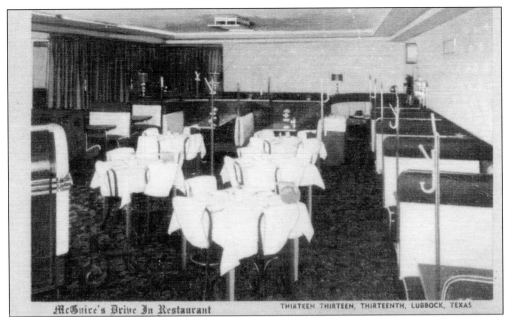

McGuire's Drive-in Restaurant, c. 1950 (Natural Color—Willens and Company).
"The place to eat," McGuire's was located at 1313 Thirteenth Street in downtown Lubbock. The restaurant opened on December 13, 1939, with 13 employees. There is no record if the owner, Fraser McGuire, had good luck or bad luck in his restaurant with the use of so many 13, but this postcard claims "pleasant surroundings with excellent service and food. You are always welcome at McGuire's." This building was near the present-day Chamber of Commerce Building.

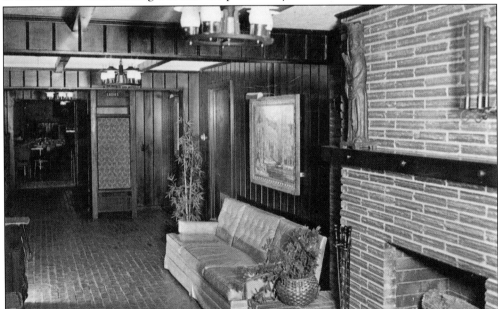

Country Inn Motel, c. 1968 (Dexter Press—American Industrial Pictures). This postcard shows the lobby of the Country Inn Motel, located at 4105 Nineteenth Street in Lubbock. The motel had a 24-hour restaurant and was located near the Texas Tech campus and the medical district. The Country Inn is still in operation at the same location in Lubbock.

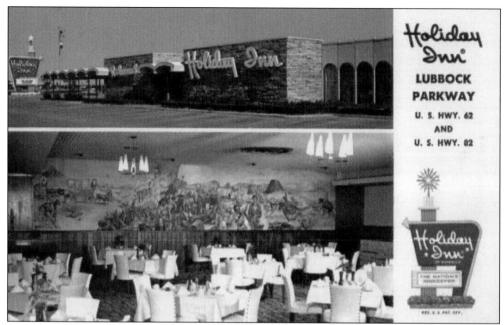

HOLIDAY INN PARKWAY, LUBBOCK, TEXAS, C. 1970 (CURTEICH). This Holiday Inn was located on Highways 62 and 82 East at Parkway Drive. Most notable about this Holiday Inn was the mural of Texas history in the large dining room, as seen in this postcard.

IN TOWN INN, LUBBOCK, TEXAS, POSTMARKED AUGUST 3, 1970 (DEXTER PRESS—AMERICAN INDUSTRIAL PICTURES). The In Town Inn had the distinction in the late 1960s and early 1970s of being Lubbock's only downtown motor hotel. It was also very close to the path of the destructive tornado of May 11, 1970, but sustained little damage in the storm. In fact, the writer of this postcard says, "This town still has many scars from the May 11 tornado."

Nine

PEOPLE, PLACES AND EVENTS

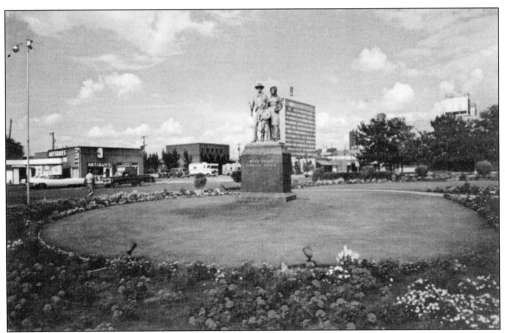

WEST TEXAS PIONEER FAMILY STATUE, C. 1972 (ARMSTRONG'S WESTERN FOTOCOLOR). Jack Payne, the first president of American State Bank, wanted to honor West Texas pioneer families with a statue. The *West Texas Pioneer Family* statue in downtown Lubbock was completed in 1971 as a tribute to those who settled in West Texas between 1890 and 1910. It is located on the grounds of American State Bank at 1401 Avenue Q.

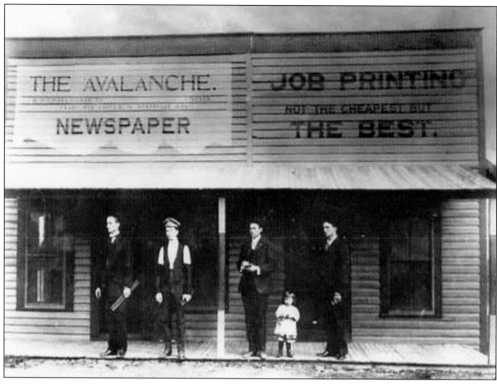

LUBBOCK AVALANCHE.

LUBBOCK COUNTY IS *THE* BANNER COUNTY OF THE PLAINS.

VOL. I. LUBBOCK LUBBOCK COUNTY, TEXAS, FRIDAY, MAY 4, 1900. NO.

J. D. CALDWELL,
DEALER IN
Dry Goods, Boots,
Shoes, Hats, Notions,
GROCERIES, HARDWARE AND LEATHER GOODS.
A NICE LINE OF MILLINERY
Farm and Ranch Supplies a Speciality.
Mail Orders promptly filled.

NEW FIRM,
NEW GOODS,
NEW PRICES!
WAYLAND AND FLETCHER.
First Class

DRUG STORE.
We carry a full and complete line of
PURE DRUGS,

L. J. HICKERSON.
Contractor Builder, Cabinet Work-
man And Painter.
LUBBOCK. TEXAS.

LUBBOCK *AVALANCHE-JOURNAL*, 1900. J. J. Dillard founded the *Lubbock Avalanche* on May 4, 1900. Dillard had kept the premiere of the newspaper a secret and named it the *Avalanche* because he wanted to surprise the citizens of Lubbock and hit them with an "avalanche" of news. The image above shows Dillard (far left) and his partner Thad Tubbs (far right) in front of their office about 1900. Dillard sold the paper to James L. Dow in 1908. The image at left shows the first issue of the *Lubbock Avalanche* on May 4, 1900. The paper became a daily in 1922 and ended up absorbing the *Plains Agricultural Journal* in 1926, creating the present-day *Lubbock Avalanche-Journal*. (Both, courtesy of the *Lubbock Avalanche-Journal*.)

st Texas
eather

LUBBOCK EVENING JOURNAL

Final Edition

For Classified Ads Dial PO5-9311

NO. 115

LUBBOCK, TEXAS, "The Hub Of The Plains" TUESDAY, FEBRUARY 3, 1959

26 Pages Today

ubbock Rock 'N' Roll Star Killed

rucks Near one

AMERICAN CLAIMED TRIGGERMAN

Plot To Kill Castro Charged

ns Charge Trying Incident

(AP)—The So-
dsv held a U.S.
of four cargo
re soldiers on
rman autobahn
of the West Ger
The convoy was
Berlin to West

y charged that the
en detained for
ure with the "ob-
el stealing an in-
ternile lifeline.
y was handed two
and demands for

s Beg Down
at Union brushed
Negotiations for
convoy topped

le charge refused
Monday night for
ie open charge of
orest. He and his
night muffled in

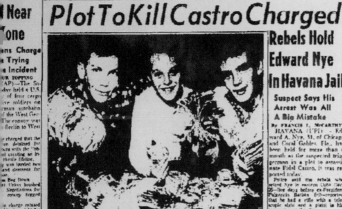

FISTFUL OF MONEY—That's nearly $18,000 worth of greenbacks the boys are sifting through. They found it in a paper bag in a vacant lot in Buffalo, N.Y. while they were tracking rabbits. Police are trying to find out where it came from. The happy treasure finders are, left to right

Rebels Hold Edward Nye In Havana Jail

Suspect Says His Arrest Was All A Big Mistake

By FRANCIS L. McCARTHY
HAVANA (UPI) – Ed
ward A. Nye, 33, of Chicago
and Coral Gables, Fla., has
been held for more than a
month as the suspected trig-
german in a plot to assassi-
nate Fidel Castro, it was re-
ported today.

Police said the rebels who
seized Nye in eastern Cuba Dec.
25—five days before ex-President
Fulgencio Batista fled—reported
that he had a rifle with a tele-
scopic sight and a pistol in his
possession at the time.

All A Big Mistake
Nye, who is being held at a po-
lice station here, told UPI that he
never has heard what charges

SLOW WARMUP STARTS

Sun Cracks Icy Mantle In Texas

BUDDY HOLLY
... Killed In Iowa Air Crash

Buddy Holly Three Others In Air Crash

Ritchie Valens, J. P. Richardson, Pilot Also Dead

Buddy Holly, 22-year-
Lubbock rock 'n' roll sing
star, was killed along w
three other men in the cr
of a light chartered pla
northwest of Mason C
Iowa, this morning, the
sociated Press reported.

Two of the other victi
Ritchie Valens, 21, Los Ange
and J. P. "Big Bopper" Riche
son, Beaumont, also were
ically known rock 'n' roll a
ers.

The fourth person killed w
Roger Peterson, the pilot.
Clear Lake, Iowa.

Parents Live Here
Holly, whose parents are M
and Mrs. L. O. Holly, 1811 3
St., was with a troupe of re
'n' roll performers currently to
ing the country on one-nig
stands.

Young Holly married a nativ
New York girl about six mont
ago. Her whereabouts was n
immediately available.

The Associated Press an

LUBBOCK EVENING JOURNAL, FEBRUARY 3, 1959. Charles Hardin "Buddy Holly" Holley was born and raised in Lubbock and to this day remains one of the most influential artists in the history of rock and roll. Buddy was born in Lubbock on September 7, 1936, and played in his own band with friend Bob Montgomery in junior high school and later at Lubbock High School. In 1955, Buddy saw a show in Lubbock that featured Elvis Presley and was greatly influenced. Buddy Holly and his band, the Crickets, became famous after they recorded "That'll Be the Day" in 1957. On February 2, 1959, after performing in the Winter Dance Party, in Clear Lake, Iowa, he was killed in a plane crash. Also killed in the crash were Ritchie Valens and J. P. Richardson, a 28-year-old disc jockey from Beaumont, Texas, better known as the "Big Bopper." This is the *Lubbock Evening Journal* announcing the news of Buddy Holly's death. He is buried in the City of Lubbock Cemetery. (Courtesy of the *Lubbock Avalanche-Journal*.)

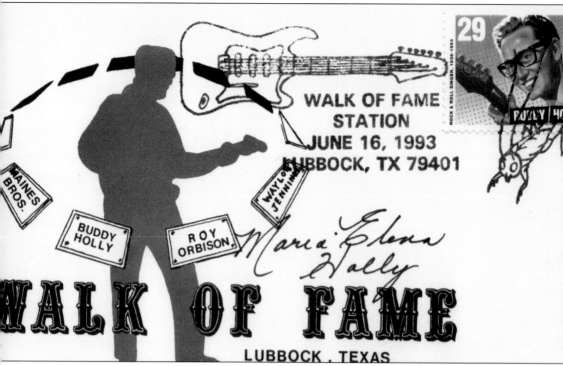

WALK OF FAME STATION
JUNE 16, 1993
LUBBOCK, TX 79401

MAINES BROS.

BUDDY HOLLY

WAYLON JENNINGS

ROY ORBISON

WALK OF FAME

LUBBOCK, TEXAS

WALK OF FAME, LUBBOCK, TEXAS, JUNE 16, 1993. Shown here is a commemorative envelope for the Buddy Holly stamp that honors the West Texas Walk of Fame in downtown Lubbock, near the Lubbock Memorial Civic Center. To preserve and share the rich musical heritage and contributions from many gifted people in the field of music and entertainment from the area, the Lubbock Walk of Fame was dedicated September 6, 1980, according to the City of Lubbock. Inductees to the West Texas Walk of Fame include Waylon Jennings, Mac Davis, the Maines brothers, Roy Orbison, the Crickets, Tanya Tucker, and many other notable names. In 1996, Civic Lubbock, Inc., envisioned a tribute area that would also recognize citizens of the Lubbock region who have devoted a significant part of their lives to the development, promotion, or production of regional art, music, or entertainment. The West Texas Terrace is located just west of the Buddy Holly statue and the Walk of Fame. On September 28, 1995, the Memorial Civic Center Entrance Plaza was officially changed to the Buddy Holly Plaza. The terrace was formally dedicated during induction ceremonies in May 1996.

SKILLETT RANCH WINDMILL, 1991.
John Keithly Caraway, who originally
planted this mulberry tree on his home
site in 1892, owned the Skillett Ranch.
At the time, the tree and windmill were
approximately 5 miles from the Lubbock
city limits. As Lubbock expanded
over the years, sections of the ranch
were sold, and many of the remaining
sections were divided among children
and grandchildren. A portion of the
property, most of which had become
the Winchester Square Shopping Center
at Fiftieth Street and Indiana Avenue,
remained in Caraway family hands until
it was sold in 1984. The mulberry tree
symbolized the ranch and was cut down at
the age of 104 in 1996. The windmill was
meticulously removed and placed across
the street at City Bank, where it still
stands today as a symbol of early ranch
days in the Lubbock area. (Photographs
by Ann English Hill.)

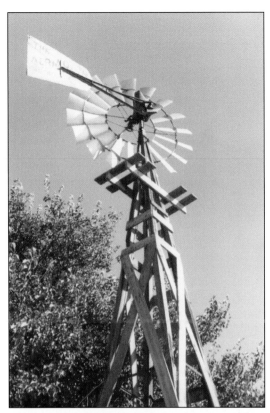

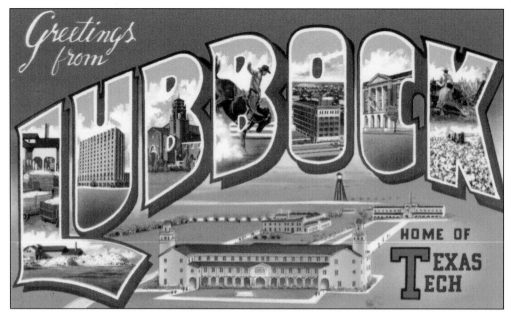

GREETINGS FROM LUBBOCK, C. 1943 (CURTEICH—C. T. ART—COLORTONE). Lubbock has been called the "Hub of the Plains" (or "Hub City of the Plains" or "Hub City") since at least 1909. Lubbock's nickname derives from being the economy, education, and health care hub of a multi-county region that is commonly called the South Plains. The area is the largest contiguous cotton-growing region in the world and is heavily dependent on irrigation water drawn from the Ogallala Aquifer. Shown here are the front and back of a multi-postcard package from 1943. All described in this book, the postcards in this package show various scenes and buildings in Lubbock and on the Texas Tech campus.

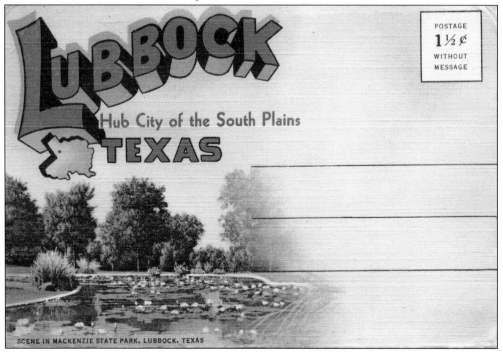

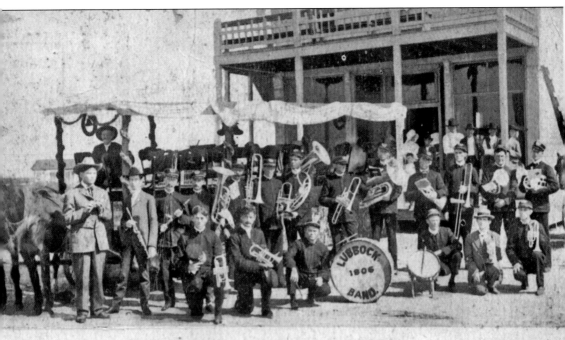

After rendering "Dixie," July 4th, 1907, Lubbock, Texas

LUBBOCK BAND, 1908. This is a real photo postcard of the Lubbock Band "after rendering 'Dixie,' July 4, 1907, Lubbock, Texas." During the very early days of the city, Lubbock had a town band that played at most local events and the festivities on July Fourth. As Texas Tech and their band grew and developed, the city band appeared less often and eventually faded. But one tradition that kept going strong and expanding was the July Fourth celebrations. By 1991, the Fourth on Broadway Festival became the city's annual July Fourth celebration. During the early years, the evening concert and fireworks were held at the civic center, but in 1999, the Fourth on Broadway Festivals committee decided to move the evening events to Mackenzie Park. The festival attracts around 100,000 people each year and is considered to be the largest free festival in the state of Texas.

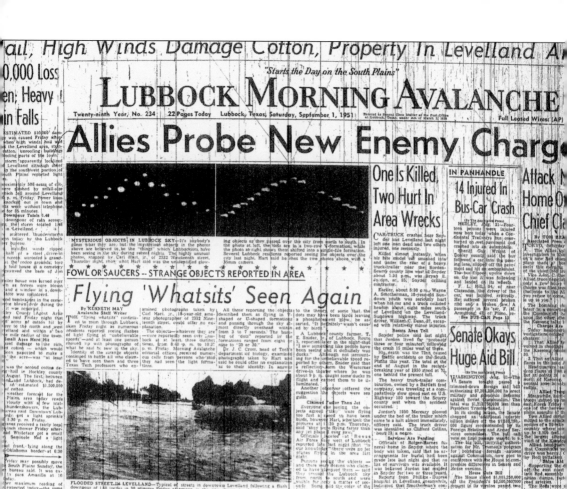

Lubbock Morning Avalanche, **September 1, 1951.** At 9:10 p.m. on August 25, 1951, Dr. W. I. Robinson, a professor of geology at Texas Tech, stood in his backyard with Dr. A. G. Oberg, a professor of chemical engineering, and Prof. W. L. Ducker, the head of the Department of Petroleum Engineering. Suddenly, all three men saw a number of lights move noiselessly across the sky, from horizon to horizon, in just a few seconds. Hundreds of nonscientific observers around Lubbock saw as many as three flights of these mysterious lights. Later, on August 30, 1951, eighteen-year-old Carl Hart Jr. took several photographs of the lights. The three Texas Tech professors examined the photographs but could find no explanation for the lights. To this day, there are those who contend that UFOs visited Lubbock, while others say that it was merely a natural phenomenon. No one really can say for sure. This is the *Lubbock Avalanche-Journal* of September 1, 1951, reporting on the phenomenon. (Courtesy of the *Lubbock Avalanche-Journal*.)

CITY DRUG STORES

NUMBER ONE		NUMBER TWO
1017 BROADWAY		1115 BROADWAY
PHONE 601		PHONE 1720

——————— TWO FRIENDLY STORES ———————

HEADQUARTERS
————— *for* —————

Drugs	Leather Purses	School Supplies
Sundries	Toilet Articles	Books & Bibles
	Stationery	Art Pictures

STORE NO. 2 HAS SODA FOUNTAIN SERVICE

WOOD PRINTING CO. [SEE OTHER SIDE]

CITY DRUGSTORES AND TEXAS TECH MATADOR FOOTBALL SCHEDULE, 1928. Shown are the front and back of an early example of a football schedule card that was produced by local businesses to support the Texas Tech football program. This card is from the 1928 football season and was produced by City Drugstores, which had two locations, both on Broadway, on each side of Texas Avenue. This was the first year that the Matadors played the University of Texas, and Texas won 12-0. The Matadors were 4-4-1 during the 1928 season, with wins only against Schreiner Institute, St. Edward's, McMurry, and West Texas Teachers College. The tie came at Daniel Baker College on November 3. The head coach in 1928 was Ewing Y. Freeland. Tech was not affiliated with any football conference until 1932, when it became part of the Border Intercollegiate Athletic Association.

1928 TEXAS TECH 1928

MATADOR FOOTBALL SCHEDULE

Sept.	29	Schreiner Institute of Kerrville at Lubbock
Oct.	6	Texas University of Austin at Austin
	13	St. Edwards University of Austin at Lubbock
	20	McMurry College of Abilene at Lubbock
	27	T. C. U. of Fort Worth at Fort Worth
Nov.	3	D. B. C. of Brownwood at Brownwood
	10	Abilene Christian College of Abilene at Lubbock
	17	Simmons University of Abilene at Lubbock
	29	W. T. T. C. of Canyon at Canyon

[SEE OTHER SIDE]

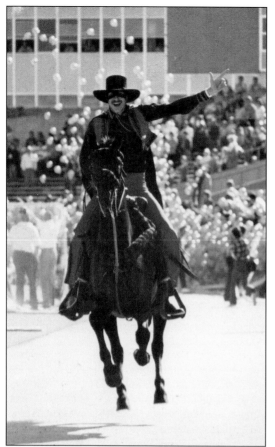

TEXAS TECH FOOTBALL TRADITION, 1976 (BOTH, ARMSTRONG'S WESTERN FOTOCOLOR). The home of Texas Tech football is Jones AT&T Stadium. Completed in 1947 and named for former Texas Tech president Clifford B. Jones and his wife Audrey, Jones AT&T Stadium originally seated 18,000. The first game was played on November 29, 1947, with a 14-6 Texas Tech victory over Hardin-Simmons. Following the last game of the 1959 season, the stadium was widened to the east for additional seating, and the playing field was lowered to a depth of 28 feet. Successive additions in 1969 and 1972 took the stadium to its current seating capacity of 50,050. Texas Tech football is known for many colorful traditions, such as the Masked Rider leading the team onto the field, which is seen in the postcard at left, and the fabulous halftime shows performed by the Goin' Band From Raiderland, seen in the postcard below. The band was the 1998 recipient of the prestigious Sudler Trophy as the nation's top marching band.

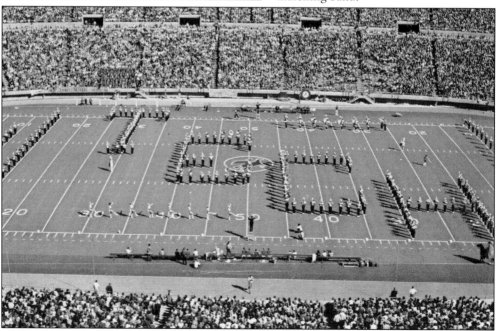

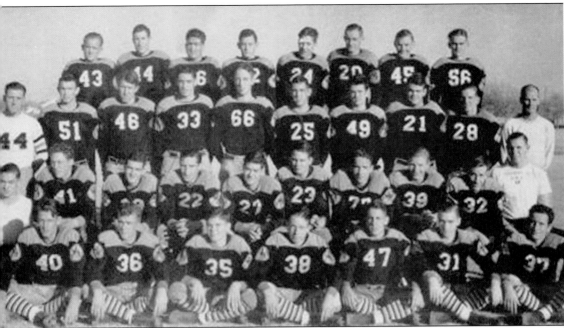

Lubbock High Westerners Football Team, 1939. The 1939 Lubbock High Westerners started the season by losing three of their first four games and went into district play that year without any momentum. After beating Pampa and Borger by a combined score of 46-0 to open district play, things seemed to be turning back in the right direction for the Westerners. But then coach Weldon Chapman died suddenly after the Borger game, leaving the team stunned. A win over Plainview and a non-district victory over Hobbs, New Mexico, set up a showdown for the district championship at Amarillo's Butler Field. Amarillo was considered the powerhouse of West Texas at that time. But the Westerners were a team of destiny. They would score playoff wins over Electra, Sweetwater, and Dallas Woodrow Wilson, with a combined score of 40-0. These victories meant the team would play for the state title game against Waco on December 20, 1939, at the Cotton Bowl in Dallas. Waco was led by legendary coach Paul Tyson and was considered a huge favorite to claim another state championship. But the Westerners were able to overcome all odds in 1939, and the state football championship trophy was brought home to Lubbock. (Courtesy of the *Lubbock Avalanche-Journal*.)

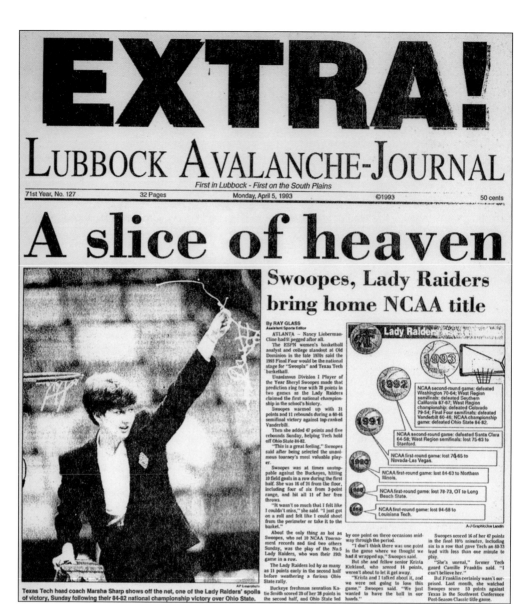

EXTRA!

LUBBOCK AVALANCHE-JOURNAL

First in Lubbock - First on the South Plains

71st Year, No. 127 · 32 Pages · Monday, April 5, 1993 · ©1993 · 50 cents

A slice of heaven

Swoopes, Lady Raiders bring home NCAA title

By RAY GLASS
Assistant Sports Editor

ATLANTA — Nancy Lieberman-Cline had it pegged after all.

The ESPN women's basketball analyst and college standout at Old Dominion in the late 1970s said the 1993 Final Four would be the national stage for "Swoopsa" and Texas Tech basketball.

Unanimous Division I Player of the Year Sheryl Swoopes made that prediction ring true with 78 points in two games as the Lady Raiders claimed the first national championship in the school's history.

Swoopes warmed up with 31 points and 11 rebounds during a 60-46 semifinal victory against top-ranked Vanderbilt.

Then she added 47 points and five rebounds Sunday, helping Tech hold off Ohio State 84-82.

"This is a great feeling," Swoopes said after being selected the unanimous tourney's most valuable player.

Swoopes was at times unstoppable against the Buckeyes, hitting 10 field goals in a row during the first half. She was 16 of 24 from the floor, including four of six from 3-point range, and hit all 11 of her free throws.

"It wasn't so much that I felt like I couldn't miss," she said. "I just got on a roll and felt like I could shoot from the perimeter or take it to the basket."

About the only thing as hot as Swoopes, who set 10 NCAA Tournament records and tied two others Sunday, was the play of the No.5 Lady Raiders, who won their 19th game in a row.

The Lady Raiders led by as many as 11 points early in the second half before weathering a furious Ohio State rally.

Buckeye freshman sensation Katie Smith scored 20 of her 28 points in the second half, and Ohio State led

by one point on three occasions midway through the period.

"I don't think there was one point in the game where we thought we had it wrapped up," Swoopes said.

But she and fellow senior Krista Kirkland, who scored 14 points, weren't about to let it get away.

"Krista and I talked about it, and we were not going to lose this game," Swoopes said. "We just wanted to have the ball in our hands."

Swoopes scored 16 of her 47 points in the final 10½ minutes, including six in a row that gave Tech an 80-73 lead with less than one minute to play.

"She's unreal," former Tech guard Camille Franklin said. "I can't believe her."

But Franklin certainly wasn't surprised. Last month, she watched Swoopes score 53 points against Texas in the Southwest Conference Post-Season Classic title game.

Lady Raiders

1993 — NCAA second-round game: defeated Washington 70-64; West Region semifinals: defeated Southern California 87-67; West Region championship: defeated Colorado 79-54; Final Four semifinals: defeated Vanderbilt 60-46; NCAA championship game: defeated Ohio State 84-82.

1992 — NCAA second-round game: defeated Santa Clara 64-58; West Region semifinals: lost 75-63 to Stanford.

1991 — NCAA first-round game: lost 70-65 to Nevada-Las Vegas.

1990 — NCAA first-round game: lost 84-63 to Northern Illinois.

1989 — NCAA first-round game: lost 78-73, OT to Long Beach State.

1988 — NCAA first-round game: lost 94-68 to Louisiana Tech.

A-J Graphic/Joe Landin

Texas Tech head coach Marsha Sharp shows off the net, one of the Lady Raiders' spoils of victory, Sunday following their 84-82 national championship victory over Ohio State.
AP Laserphoto

LUBBOCK AVALANCHE-JOURNAL, MONDAY, APRIL 5, 1993. The *Avalanche-Journal* published a special extra edition the morning after the Lady Raiders basketball team won the NCAA National Championship in 1993. It was only the second extra edition ever published by the *Avalanche-Journal*, the first one coming on December 7, 1941, announcing the Japanese attack on Pearl Harbor. Led by star player Sheryl Swoopes and head coach Marsha Sharp, the Texas Tech Lady Raiders culminated the season with a 19-game winning streak and defeated Ohio State University 84-82 in the National Championship game on April 4. On the evening of April 5, when the team returned to Lubbock, more than 40,000 fans packed the stands to celebrate the first national championship won by a Texas Tech team. Swoopes averaged 28.1 points per game for the season and turned it up a notch in the postseason, scoring 177 points in five NCAA Tournament games and setting a record in the championship. She set a total of 10 NCAA Tournament records en route to national player of the year honors. (Courtesy of the *Lubbock Avalanche-Journal*.)

Texas Tech Carol of Lights, c. 1975 (Herald Photograph—L. W. Jacobs). To celebrate the holiday season, Texas Tech holds an annual event called the Carol of Lights. The event starts off with the Texas Tech University Combined Choirs performing selections of classic holiday songs at the Science Quadrangle. When the lighting ceremony commences, over 25,000 red, white, and orange lights illuminate the 13 buildings surrounding memorial circle. According to the university, the tradition started in 1959 with the idea to cover the Science Quadrangle and the Administration Building with lights. But students were away on Christmas break and did not see the display, so the next year, the Residence Hall Association created the Christmas Sing, which is now known as the Carol of Lights, and it is performed each year prior to the closing of the residence halls for Christmas break. This postcard shows the Administration Building tower through one of the arches in the Science Quad.

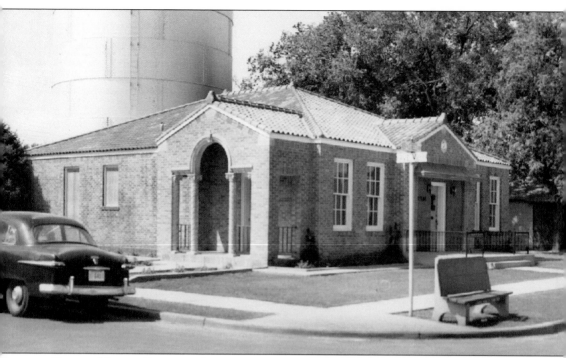

UNITED WAY OF LUBBOCK BUILDING, C. 1955. The Lubbock Area United Way began as the Lubbock Community Chest in 1946 with six member agencies and a charitable campaign goal of $92,173. In line with similar "community chests" that were forming nation-wide, this group planned and coordinated local services and conducted a single fund-raising campaign for its member agencies. The Lubbock Community Chest continued to evolve and was renamed the United Fund in 1961, the United Way of Lubbock in 1974, and finally the Lubbock Area United Way in 2002. Since its inception in 1946, the Lubbock Area United Way has been lead by a board of community volunteers that relentlessly seeks to create a better community and combines this diligence with decisive action for today and discerning foresight of the future. Shown here is the United Way building on Fifteenth Street and Avenue V in 1955. A few years later, the offices of United Way moved to the old Fire Station No. 2 on Nineteenth Street. The offices now reside at 1655 Main Street. (Courtesy of the Lubbock Area United Way.)

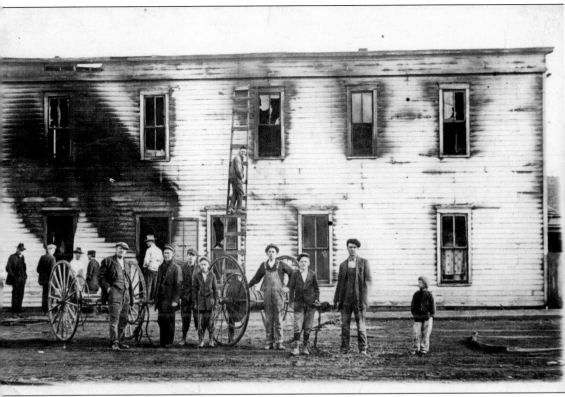

DOWNTOWN FIRE DAMAGE, 1911. The big story of 1911 was the fire in Lubbock in November that destroyed much of the downtown area. There were numerous fires in 1911 all over the world, including the disastrous Triangle Shirtwaist Factory Fire in New York. Many buildings were still wood structures, and the numerous fires led builders to construct more and more brick and concrete buildings. The Lubbock fire started in the basement of the Lubbock Mercantile Company's building, which was a two-story, concrete-block building located on the southwest corner of the square and which was considered one of the safest buildings in the city. Merchandise occupied the basement and first floor, while lawyers, doctors, and people in real estate had their offices on the second floor. It was a devastating loss to the young community. The fire led to a push for improvement in fire prevention and fire fighting in the city. This real photo postcard shows some damage from the fire in downtown Lubbock. It was never determined how the fire started.

SEASON
AUTO TICKET

$1.00 28th Annual $1.00

Panhandle South Plains Fair

October 6, 7, 8, 9, 10, 11, 1941
LUBBOCK, TEXAS

ISSUED TO _____

To be good the recipient must have written his name above and in case of doubt the holder will be required to rewrite the name for comparison, the object being to prevent imposition upon the Association in case of loss of ticket. Not responsible for loss of car by fire or theft.

H. D. GRANT, President A. B. DAVIS, Manager

SEASON AUTO TICKET, SOUTH PLAINS FAIR, 1941. The first South Plains Fair was held in the fall of 1914, according to the fair. In 1921, the fair brought the first carnival to the city. Culinary, sewing, and craft categories were added to provide competition for women. The first livestock competitions also began in 1921. By 1928, the fair was lengthened from 3 days to 6. In 1932, the fair opened and closed in driving downpours, and the crowd dipped to 68,000. Attendance held steady around the 125,000 mark until 1942, when the fair was canceled as the nation headed into World War II. In 1946, the fair returned, along with peacetime, and attendance climbed back over 100,000 by 1947. Major headlining stars came to Lubbock following the construction of the Fairpark Coliseum in 1954. The first act to perform on the stage was the touring wing of the Grand Ole Opry with Elvis Presley in 1956, and hundreds of other stars have performed here ever since. Shown here is a season parking pass from the 1941 fair, which was the last fair held until after World War II.

NATIONAL RANCHING HERITAGE CENTER, 1978 (ABOVE, McGREW COLOR GRAPHICS—KARL H. REICHEL; RIGHT, PHOTOGRAPH BY RUSSELL HILL). The National Ranching Heritage Center is a museum and historical park in Lubbock, Texas, established to preserve the history of ranching, pioneer life, and the development of the livestock industry in North America, according to the center. Forty-five authentic furnished ranch buildings and structures, relocated from their original sites, show the evolution of ranch life from the late 18th century through the 1930s. The center was dedicated on July 2, 1976, during a weekend-long bicentennial celebration in Lubbock. Visitors to the National Ranching Heritage Center will see historic windmills, dugouts, barns, corrals and pens, a bunkhouse, a one-room schoolhouse, a blacksmith shop, ranch headquarters buildings, a locomotive, stock cars, a depot, a cabin made of cactus stalks and mud chinking, and an elegant two-story ranch home that was purchased from a mail-order catalog. Each building has been authentically restored, furnished, or outfitted to reflect period correctness.

LUBBOCK AVALANCHE-JOURNAL

40th Year, No. 165 8 Pages Lubbock, Texas, Tuesday Morning, May 12, 1970 Price 10 Cents ★ Full Leased Wires: (AP) (UPI)

MORNIN

Twister Smashes Lubbock
20 Dead, Hundreds Injure

Water Shortage Reported

By KENNETH MAY
Public Affairs Director
Avalanche-Journal

...ster officials were review-... situation in the emergen-... erating center at City Hall ... 5 a.m. today.

...ter is in critical short-... City Manager Bill Black-...old the group. "We have ...bout five million gallons in ...e and we normally use ...35 million gallons per day ... time of year."

Wahl, city director of ...works, said crews were ...ng way to the sand hills ...near Muleshoe to start ...ng water toward the city ... pumping station from ...we get Canadian River ...is without power and the ...ment is too large to run ...liary power," Wahl said.

...should have water on the ...here from the sand hills ... morning. It takes about ...hours for it to get here ...ain problems now is to ...wer to the Holly Avenue ...ting station to keep our ... 5 water station working ...lso need power at the ...s disposal plant. We have ...age problem building up

... nty seven National Guard ...and police officers and ...mes from throughout the ...

WATER on Page 2)

Touchdown of the Lubbock tornado came in the corner of University Avenue and 19th Street (small funnel). Traveling northeast, the funnel cut a path through nearly 200 blocks of the city, hitting hardest at the corner of Avenue Q and 15th Street, witnesses said. The tornado continued northeast, shaving the east side of Lubbock Municipal Airport.

Map by MIKE H. PRICE

Damages Run Into Million
National Guard Is Called

By The Avalanche-Journal Staff

A massive tornado ripped through the heart of downtown Lubbock late Monday night — leaving de... struction in the millions, and a city badly crippled.

Unofficial estimates placed the dead at 2 a.m. today as high as 20, with more than 200 hurt, at lea... those hospitalized. However other reports indicated the toll might not go above 12.

The twister which also was accompanied on the fringe of its spiraling funnel with winds clocked ... of 200 m.p.h., left damage in the area generally bordered by 19th Street and University Avenue and in... north and east of that point.

Damage easily will run into the millions of dollars. At 2 a.m. as an eerie quiet settled over the torn... section, rescue workers con-
tinued to dig into shattered
homes and crumbled build-
ings for possible other vic-
tims of the savage storm —
the first time in the city's
70 year history it has been hit
full force by a tornado.

The hardest hit area of the
business section appeared to be
in a triangle starting at 15th
and Avenue Q and spreading
out as the funnel gouged its de-
structive path northeastward.

Standing starkly against the
blacked out sky lighted by
emergency power was the First
National Bank Building — huge
holes torn in its glass and mar-
ble, decayed debris and mar-
ble and concrete blocks, some
of which fell five or six stories,
crushed cars parked around the
building.

Early today a state of
emergency existed in a large
part of the city, with police,
Department of Public Safety
and other officials patrolling the
streets.

A curfew has been ordered
by the city's mayor Jim
Granberry.

An appeal was issued
throughout the city for residents

70-Year Record Is
Crushed by Torna...

By JAY HARRIS
Avalanche Journal Staff

It finally happened to Lub-
bock.

A savage tornado striking out
of green soupy skies left death
and destruction across a city
that for more than 70 years had
some how escaped terrible
twisters which often dotted the
area landscape. The scene was
set during a late muggy after-
noon when thunderheads built
up south and southwest of the
city.

By 7 p.m. reports of hail and
scattered rainfall were coming
in from rural communities only
a few miles from the southern
city limits. But no one was ov-
erly alarmed at the time

By 7:30 p.m. the storm sys-
tem had taken on a complete-
self an unusual dir...
different hue and the Lubbock
weather bureau was issuing a area
across the counties

Members of the Lubbock Fire-
men's association were playing
host to a number of the city's
news media at an annual din-
ner. Suddenly the word was
flashed to City Manager Bill
Blackwell and Fire Chief Her-
schel Sharp, who told them that
tornado cloud — in the storm
which was building on the south
eastern city limits.

The boiling purple, green and
black clouds started moving

slowly to the northw...
self an unusual dir...
weather bureau ... ofi-
cials, and others w...
Emergency personne...
ficials, and others w...
men command post at...
host city hall and ot...
as reports of bas...
her ... was hail on ...
units drove into the...
Police and Highw...
a 5 to p m with seve...
being stopped in the...
by blinding rain and...
The storm moved...
being her next hour T...
Bureau placed the ce...

LUBBOCK AVALANCHE-JOURNAL, MAY 12, 1970. Lubbock was hit by an F-5 tornado on the night of May 11, 1970. The power went out at 9:46 p.m., and the tornado touched near Nineteenth Street and University Avenue, travelling northeast through the heart of the city. Winds in the storm were clocked at over 250 miles per hour and wreaked havoc and destruction through major portions of the downtown area and at the Lubbock Country Club in the northern part of the city, near the airport. Shown here is the May 12, 1970, edition of the *Lubbock Avalanche-Journal*, which was a slim but information-filled piece of work. The eight-page edition contained only a few of the top national and international stories of the day, two pages of sports, and the stocks and commodities prices. There was no advertising and no comics page. The tornado had damaged the *Avalanche-Journal*'s building on Eighth Street and Avenue J, so staff members published the first printed words on the killer storm from a makeshift newsroom that did not have electricity or telephone lines. Due to damage to the building, the 60,000 copies of the paper on May 12, 1970, were printed at the *Amarillo Globe-News* and trucked to Lubbock. (Courtesy of the *Lubbock Avalanche-Journal*.)

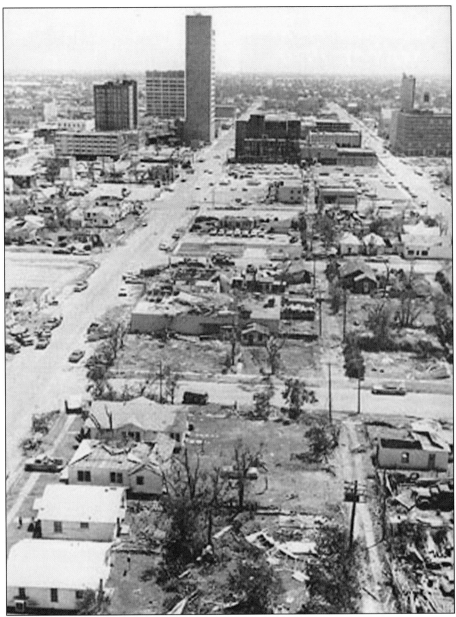

TORNADO DAMAGE, MAY 12, 1970. Estimated 250-mile-per-hour winds froze clocks in the 20-story Great Plains Life Building at precisely 9:45 p.m. By 10:00 p.m., 15 square miles between downtown and the airport were left powerless and debris-riddled. The predominantly Hispanic Guadalupe neighborhood, consisting of old wood-frame or stucco homes, and parts of the affluent Mesa Road area near the Lubbock Country Club were leveled. The storm's zone of extensive damage cut a 3/4-mile-wide path from Seventh Street and Avenue Q, angling to the northeast, to Loop 289 and Highway 87, and then to Lubbock Regional Airport. By the time the tornado reached the airport, it had reduced to a 1/2-mile-wide path of devastation. This image shows the path of destruction in downtown Lubbock on May 12, 1970. The destruction included 26 persons dead, over 1,500 persons wounded, and over 600 commercial buildings and 949 family housing units damaged or destroyed. (Courtesy of the *Lubbock Avalanche-Journal*.)

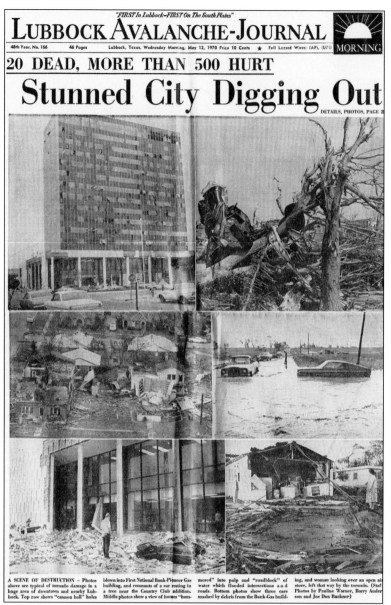

LUBBOCK AVALANCHE-JOURNAL, MAY 13, 1970. Despite the devastation to the local economy, Lubbock residents approved $13.6 million in bonds for a disaster recovery package that featured $7.8 million for the Memorial Civic Center, $1.2 million for the public library, $2.8 million for the Canyon Lakes project, and $1.8 million for parks. The civic center project—as well as a monument to those who died in the storm—became the focus for a virtual rebirth of the downtown area. Other projects that would cluster around the facility included a new West Texas Hospital, headquarters for the Texas Department of Public Safety, two major hotels, and the IBM Building. The storm had hit at a time when Lubbock's growth rate had slowed down after a decade with a population and construction boom. Lubbock also had been struggling with sharp divisions between the various races, but the tornado seemed to dissolve people's differences and bring the community closer together. Although a terrible tragedy, the storm sparked a decade of growth and prosperity. (Courtesy of the *Lubbock Avalanche-Journal*.)

Tornado Damage, May 13, 1970.
These images show some of the severe damage done to the Great Plains Life Building by the May 11, 1970, tornado. The building at the corner of Broadway and Avenue L was six blocks away from the direct path of the twister. Researchers and city inspectors found that the building's steel frame suffered a 12-inch permanent deformation on the south side, and 60 percent of the window panes were broken either by wind pressure or storm-flung debris. For days, radio and television reports predicted the building would collapse, but engineers, hired by the city, found the prediction to be inaccurate. It was not until five years later that people began to reoccupy the 271-foot-tall building, which had been renamed the Metro Tower. (Both, courtesy of the *Lubbock Avalanche-Journal*.)

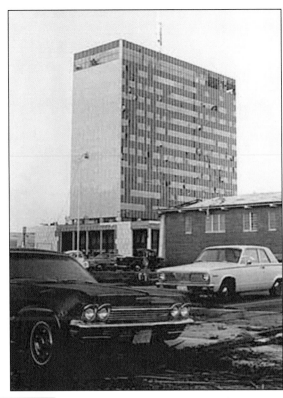

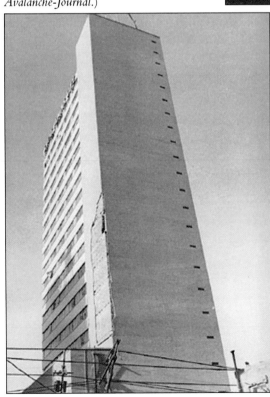

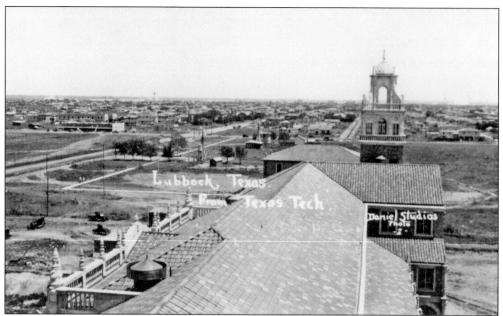

DANIEL STUDIOS, LUBBOCK, TEXAS C. 1926 (BOTH, DANIEL STUDIOS, LUBBOCK, TEXAS).
Daniel Studios was the predominant photography studio in Lubbock during the 1920s and 1930s. Many photo postcards of Lubbock and Texas Tech from this era were produced by Daniel Studios. Unfortunately, very little information has survived about the studio or the photographers. Much of the studio's work was done at Texas Tech, including a great deal of work for the Texas Tech annual, *La Ventana*. The top image is an aerial photograph of Lubbock taken from the bell tower of the Administration Building at Texas Tech in the early years of the school. The bottom photograph is of city hall, which was constructed at Tenth Street and Texas Avenue in 1924. According to advertising run by Daniel Studios in the Texas Tech football programs of the 1930s, the studio was located in the Bush Building in downtown Lubbock.

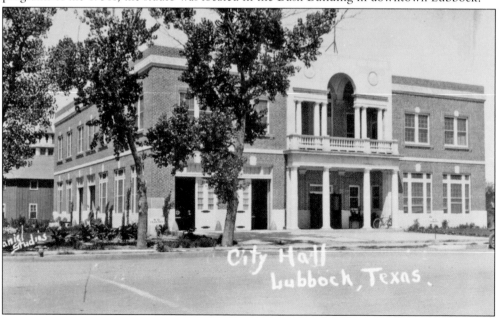

BIBLIOGRAPHY

Abbe, Donald, Paul Carlson, and David Murrah. *Lubbock and the South Plains: An Illustrated History.* Chatsworth, CA: Windsor Publications, 1989.

Abbe, Donald R. and Paul H. Carlson. *Historic Lubbock County: An Illustrated History.* San Antonio, TX: Historical Publishing Network, 2008.

City of Lubbock. www.ci.lubbock.tx.us/

Graves, Lawrence L. *A History of Lubbock.* Lubbock: West Texas Museum Association, 1962.

———. *Lubbock: From Town to City.* Lubbock: West Texas Museum Association, 1986.

Lubbock Avalanche-Journal. www.lubbockonline.com, www.lubbockcentennial.com, http://lubbockonline.com/lubbocktornado.shtml

Pollard, Norval and Doug Hensley. *Red Raiders Handbook.* Wichita, KS: The Wichita Eagle and Beacon Publishing Company, 1996.

Southwest Collection. www.swco.ttu.edu

Texas State Historical Association. www.tshonline.org/handbook/

Texas Tech University. www.ttu.edu

DISCOVER THOUSANDS OF LOCAL HISTORY BOOKS
FEATURING MILLIONS OF VINTAGE IMAGES

Arcadia Publishing, the leading local history publisher in the United States, is committed to making history accessible and meaningful through publishing books that celebrate and preserve the heritage of America's people and places.

Find more books like this at
www.arcadiapublishing.com

Search for your hometown history, your old stomping grounds, and even your favorite sports team.

Consistent with our mission to preserve history on a local level, this book was printed in South Carolina on American-made paper and manufactured entirely in the United States. Products carrying the accredited Forest Stewardship Council (FSC) label are printed on 100 percent FSC-certified paper.

MADE IN THE USA